New Revised Edition

Community Arts Workers:

Finding Voices, Making Choices

Creativity for Social Change

Edited by

Mark Webster and Glen Buglass

A book in the series

Community – Creativity – Choice – Change

Educational Heretics Press

Published 2005 by Educational Heretics Press
113 Arundel Drive, Bramcote Hills, Nottingham NG9 3FQ

Copyright © 2005 Educational Heretics Press

British Cataloguing in Publication Data

The Community Arts Workers: Finding voices, making choices
 1. Community Arts Projects 2. Social Participation
 3. Community organisation
 I. Webster, Mark and Glen Buglass
 709

ISBN 1-900219-22-0

Acknowledgements

I would like to thank everyone who has helped in the getting this book into print. Thanks particularly go to Glen Buglass, who not only contributed a chapter and co-ordinated another, but also collaborated in the editing process. Also to Janet and Roland Meighan at Educational Heretics Press without whose patience and support the book would not have made it to publication. I would personally like to extend my thanks to the all the contributers – to Sam and Kim, Max, Deb, Jonathan M, Jonathan H, Rachel, Claire, Jan and Julia. Special thanks to series designer Jon Haxby. I am also grateful to Jim Morris who came up with the original title for the book, which we retain, unaltered, for the present edition. This edition of the book is dedicated to Kate Gant, who as a colleague and friend has been, and remains, a constant source of support and inspiration.

For Rosa

Contents

Preface to the new edition

When we produced the first edition *of Finding Voices, Making Choices,* it felt as though we were casting out a bottle with a message locked inside into a very rough sea. We were not sure what to expect. It was a long time since Owen Kelly had written *Community Art and the State.* Were people actually interested in reading about Community Arts any more? Reassuringly lots of other bottles with lots of other messages came floating back. People said that the book had made them reflect on their practice, inspired them, got them to think and even made them change their minds or do things differently.

Of course the years pass and books about contemporary practice start to show their age. No less so with *Finding Voices, Making Choices* than with any other book. Since the first edition the terrain of the world of Community Arts has changed almost beyond recognition. Young people who were participating in projects when the first book was being produced, have now gone on to become community arts workers in their own right. Funding empires have risen and fallen. The Arts Council has re-established its control over its unruly regional offices and I have lost count of the number of Arts ministers who have fallen on their swords. Is there still a place for a book about the principles of Community Arts?

This was the question that I kept asking myself. The temptation was to completely rewrite the book and indeed my self-doubt about the form of the book put off the publication of the new edition for nearly two years. I am indebted to Glen Buglass who helped me to clarify how we should approach the new edition, and to the publishers who have kept faith with the process. The book was always intended as a primer for Community Arts. Clear enough to act as an introductory volume but with insights and case

histories that will make even the most experienced Community Arts activist reflect upon their approach to the work. In producing the second edition we have remained faithful to this formula while rewriting most of practical and case history sections of the chapters. If you are a first time reader of *Finding Voices, Making Choices* I hope you find the journey through its pages stimulating and thought provoking. If you are a return reader I hope we have kept your favourite bits but put in enough new material to reinvigorate you and get you back out there working creatively in communities.

The book is now part of a new series called **Community, Creativity, Choice and Change.** One of the inspirations for this series was *Finding Voices, Making Choices* so if you enjoy it there is a good chance you may enjoy some of the other books in the series.

Mark Webster

Introduction

At the age of nine, my music teacher made me stand up in front of the whole class and try to whistle a short tune she first played on the piano. After the first four notes she stopped me and asked me sit down. I was **not** one of the lucky ones to be selected to learn a musical instrument or to sing in the school choir. This was the way in which I learned that I had no ear for music, and while I might enjoy listening to others make music, it was an area of artistic endeavour that would be for ever closed to me as far as the school was concerned.

Nevertheless, I clung on to the dream that one day I would sing in a band. So I got hold of a guitar and learned how to play. Later, long after I had left school, a friend showed me that if you open your mouth and listen to what comes out anybody can sing. I had found my voice, finally, by the age of twenty-three and I was singing in a band and writing my own songs. The most fulfilling activity in my life was not developed through formal education but by myself and with my friends. School had done everything it could to make me believe that music was something done only by the talented few, and that I was certainly not one of them.

Community Arts takes as its starting point that everyone is creative and, that essentially, everyone is an artist. The Community Arts movement grew up as a response to the elitist approach of schools and arts institutions, which exclude the majority from being involved in the production of art. Throughout its short history it has sought to redefine the role of art and the role of the artist.

Community Arts is a way of describing creative activities that bring people together in their communities, and that give people the opportunity to gain new skills and new opportunities. Community Arts works to nurture the potential that exists in all communities to be creative and to find a voice to express their concerns through and using the Arts.

This book sets out to explain the Community Arts process through the eyes of some people who work with the Arts, to bring about positive changes in communities. All the writers

are experienced practitioners who are working, or have at some time worked, to develop Community Arts in Walsall, in the West Midlands, and many of the examples draw on work there. The themes, however, are universal and the writings highlight issues in contemporary practice that will be relevant to anyone interested in the development of Community Arts.

The first chapter is intended as a brief introduction to Community Arts and the Community Arts process. Each following chapter is then dedicated to exploring a key theme. Every one of these themes is a cornerstone in Community Arts practice. Chapters are split into two parts. A *keynote,* which I have written as editor, introduces and explains the theme, and an article by a contributor, selecting an issue and developing the theme, by rooting it in current work.

Why Walsall?

Walsall provides the focus and inspiration for this book for two reasons. Firstly, because 14 years of the practice of Community Arts activity in this one area has provided a solid body of developmental work. This work constitutes the successful outcome of a daring, unique experiment in local authority-based Community Arts work, and contributes something new to the developing history of Community Arts.

The second and more important reason, is that drawing on related work provides a context for debates and arguments which have echoed through the Community Arts movement since its inception. I wanted to examine this legacy through the words and ideas of some of the people responsible for its development. Because the book is part of the *Educational Heretics* series, it seemed fitting to collaborate with some people who have been responsible for developing and propounding the arch heresy that everybody has the right and the ability to participate in the Arts.

The book aims to be accessible to anyone, whatever their experience of Community Arts, and, because of the way it is organised, could serve either as a general introduction to the uninitiated, or as a provocative read for people already involved in its practice.

Chapter one

Warming Up

Definitions and Core Values

by Mark Webster

How many times have I heard people say *"I can't draw"*? The fact is, that most people do not think they are artistic or that the Arts have much to do with their lives. To many, it is just something that recalls unhappy memories of schooldays. Yet this is interesting, given the fact that we are surrounded by art products. Mass culture has bred a whole generation of art consumers but it has brought little by way of choice or diversity. Neither has it done anything to democratise the Arts or to give people the belief that its production is something in which they can actively participate.

This is not, of course, something peculiar to Britain. All western/northern industrialised countries have demonstrated the same tendency to lodge the power to define and to create art with an educational and economic elite, and to produce a population of art consumers.

Even so, every community has its break dancers, silk painters and poets. People get together to sing, to act and to tell stories - but this creativity tends to go unnoticed and unvalued and finds little representation in official culture. Its importance and significance is largely unrecognised and unacknowledged and, where cultural forms find popularity, they are quickly appropriated or co-opted by the arts establishment or the commercial arts sector.

Community Arts grew in Britain as a movement to try to re-establish the link between people and culture, to stimulate and inspire new types of activity and to value and promote latent or hidden skills and talents in communities. It attempts to give people the tools to be active, confident participators and creators,

to help communities discover, develop and use their ability to express themselves through creativity, and to find their voice.

What is Community Arts?

Community Arts is a term embracing all those activities which involve groups of people doing creative things together. What differentiates Community Arts, say, from amateur arts or the professional or commercial arts, is that:

- It promotes participation, regardless of the existing level of skill or 'talent'.

- It is undertaken by a group who either have the same collective identity, or a goal greater than the art form itself, or both.

- It is developed primarily to provide opportunities for people who through economic or social circumstance have little access to the means to participate in the Arts.

The activities are often in the form of projects and (though not exclusively) consist of workshops that lead towards an end event or end product.

The activity itself could be anything from a Community Festival to a book, a video to a dance, a mosaic to a mural, or even a combination of all these and more. Community Arts is not defined by art form but by process.

The long term effect of Community Arts work may be the setting up of a self-sustaining activity or permanent group - a writing group in a library perhaps, or a community choir. It may lead a community group to see the potential of the Arts in connection with another activity - a housing campaign, health promotion or the programme of activities for an over-sixties group.

Alternatively, it may provide access to a field of endeavour that an individual felt was previously closed to them - someone who had always enjoyed social dancing goes on to learn Bhanghra or Jazz dance. Also, its long term effect may be simply that individuals feel more empowered and confident to go on to do other things in

their lives, like taking part in more community activity or getting involved in local politics or to go into further or higher education. When projects lead to the setting up of self-sustaining activity or to the opening of a resource, this is usually termed a 'development'. It is work to bring about these 'developments' (i.e. development work) that probably does the most to authenticate Community Arts' claims to make long lasting change, and to differentiate Community Arts from other participative arts activity.

Another feature of Community Arts activity is that at some stage in a project's lifetime it involves the involvement of an artist or an arts worker. This is a breed of people who spend their time and make a living from sharing their skills with people. Their purpose is to enable them to participate in projects, learn skills and share ideas. Often these workers define themselves in terms of art-form specialisms, for example as visual artists, or as 'makers', or performers; or even more specifically, as say, video workers, digital media workers, dancers or textile workers.

Since the scale of much of the work often necessitates the involvement of more than one worker, and a considerable number of resources, teams have grown up which include workers with complimentary arts skills. In addition, projects do not simply spring out of thin air. They need to be administered, co-ordinated and managed.

As a result, the last twenty-five years has seen the rise of another breed of people called Arts Development Workers or Community Arts Development Workers. It is their job to see the potential for projects, to talk to people, to find money, to set up and manage projects and ultimately to identify potential new developments after projects have finished, and to build the outcomes of projects into policies and strategies.

There are several models for the supply of these Community Arts 'services':

Freelance - Where arts workers or development workers work independently, making partnerships with community groups or other arts agencies around specific projects.

Art form agencies - Agencies who specialise in a single art form or activity such as drama, dance or video. Their activities may be linked to a particular facility such as a community dance studio or community video studio, or they may specialise in setting up community-based projects within community facilities. Quite often they do both.

Arts organisations with Community Arts Officers or Education Officers - Within this category are all those organisations whose main activity is not participatory but who want to promote participation in the Arts or increase access to them. Such organisations include theatre groups and art galleries who often describe their work with communities and schools as *Audience Development.*

Community Arts agencies - These are organisations that exist to develop Community Arts activities in a variety of art forms based on community needs. The early model for such organisations when Community Arts as a concept was still finding its feet, was of small companies in the voluntary sector, funded by the then regional arts authorities, and local councils employing workers with a range of art form skills to work within a given catchment area. While such teams still exist, and in some cases have grown quite large, with attendant resource bases and arts centres, the past twenty years has also seen the growth of the local authority sector.

Local authorities

Most of the larger local councils now either have a Community Arts Team, a Community Arts Officer, or an Arts Development Officer who, as part of their brief, have the job of developing Community Arts. While some local authorities actually employ their own art form staff, more usually local authority officers act as brokers between local community needs and the arts organisations, or arts workers within their area. There is no set model for delivery. Sometimes local authorities are direct providers of projects and programmes of activity, while others seek a more developmental approach encouraging partnership, working cross service area within the council or in partnership with other organisations. With the large number of funding

sources now available through regeneration frameworks, and of course through the National Lottery, most local authorities have both an advisory and advocacy role in supporting voluntary and community groups in applying for funds to support Community Arts work at a local level. Some local authorities even administer their own grants fund from which it is possible to apply to set up Community Arts activity to local arts organisations.

Increasingly, the pressure is on local authorities to think regionally and to work at a strategic level. Many have argued that this will have the effect of reducing their role as direct service deliverers in the long term. This diversity of practice has led to a wide variance in philosophy, method and approach between local authorities, to the point where it is possible to say that there is no universally understood definition of what the term Community Arts actually means.

Walsall Community Arts Team

Walsall Community Arts Team is a local authority team that, while not unique, represents an important development in the way Community Arts is developed within a geographical area. It was set up in 1989, as part of a new Arts And Cultural Services Division within the brand new Leisure Services Department of Walsall Metropolitan Borough Council. Within the division, alongside the Community Arts Team, was brought the Walsall Art Gallery, the Museums section and, the then, yet to be completed, Walsall Garage, Arts and Media Centre.

Walsall is a large urban conurbation to the north west of Birmingham, consisting of four distinct towns and something around 265,000 people. To the north of the Borough is a large expanse of 1950s council housing where the population is largely white and working class. To the south and west is an area of mixed housing ranging from high rise blocks, to back-to-back terraces, home to a rich mixture of communities and cultures. All the indicators show Walsall to be a place that is economically and socially disadvantaged. By common agreement, it was also a place that in 1989 was starved of resources for the Arts.

The whole arts and cultural development, which emerged out of a process which included a cultural audit and years of planning and negotiating, had a strong community bias, and in this reflected the history and commitment of Walsall Council to producing accessible, relevant, community-focused services. The Community Arts Team, therefore, had the advantage of existing within a framework which, in theory at least, valued community-focused work, and put Community Arts work alongside its mainstream services. It was also building on a history of Community Arts provision in the Borough which had been sporadic and piecemeal but which had made some real achievements and demonstrated the potential for development.

In its first incarnation, the Team had four full-time development workers, of which I was one, and a budget to employ freelance arts workers. It was then also part of an agreement with West Midlands Arts and the Regional Arts Board, which would bring extra money into the Borough over the next three years to finance Community Arts developments.

The approach we took from the start was that of active initiators. We did not just want to wait until groups came to us, we believed that the only way we would have an effect was if we went out and found projects to get going. It was also important to us that the service was actually based on people's needs and that we were not simply parachuting in 'arty' projects which we thought would be good for people.

Early attempts to set up projects which reflected people's needs included a Banner Festival on one council estate, which was designed to bring groups together to celebrate their hopes for the future. In another area, we brought in video workers to work with several groups as part of a project to document housing problems, while another community organisation worked on a photographic project which tied into the opening of their community centre and documented their aspirations for the centre.

As our experience grew so did that of the groups we worked with, and soon people came to us to start developing their ideas. While we continued to develop new projects with new groups, there was

now also need to set up a support structure which could help groups to develop and manage their own projects.

In the fifteen years of its existence, the Community Arts Team in Walsall has developed a strong philosophy for the provision of this support, or 'development service', and a structure for its delivery. Today, the Team offers a complex programme of development work, advocacy, advice and project delivery across a whole range of agendas.

The key to its strength as it has grown, is that although it now works at a strategic level within the council and across the region it has not lost its personable hands-on approach. A member of the Team could equally find themselves being called to London to advise a government committee one day, be asked to sit in for the council's chief executive on a regional regeneration panel the following day, and then find themselves humping equipment for a community event on the next. That its annual turnover as a team is now well in excess of one million pounds has not meant it has lost any of its grass roots support, and this has been built on the very simple philosophy of agreeing what they are going to do with communities and then delivering it, exactly when and how they said they were going to deliver it.

Over the years the Team has developed some fundamental principles for the practice of Community Arts in Walsall. These are now woven into all of the work of the Team and provide the basis for the arts policy officially adopted by the Council:

- **Empowerment:** that work should empower communities in Walsall

- **Participation:** that work should seek and promote the active participation of communities

- **Access:** that all work promotes greater access to the Arts

- **Quality:** that people in Walsall deserve high quality service

- **Partnership:** that all work is done in partnership with local communities

These principles form the cornerstones on which all the work is now based, and the basis for the development of the Community Arts Service in Walsall. By focusing on these principles in turn, and by exploring the issues that arise out of them, the following chapters of the book aim to explain the power of the Community Arts process to foster change, and its ability to move things on.

Chapter two

Finding a Voice

Keynote: **Empowerment**

The concept of empowerment seems simple, or even self evident; the idea that a person, a group of people, or a community, might in some way become powerful as the result of some action done to them or actively undertaken by them. It is, clearly, a word with political overtones and when first used within Community Arts circles it was used to describe an intention. This was, that a participatory arts activity would not only give people the understanding and knowledge to undertake arts activities, but that this process would give them insight into the nature of the oppressive ways in which society functions and give them the tools to do something about it. Many practitioners made comparisons between their work and political struggles elsewhere in the world, believing that the Arts could unleash creative energies, build solidarity within communities, and give people a voice to express their aspirations and help them to build positive strategies for change.

Perhaps because of the historically strong connection between community work and Community Arts work or because of the change in the political climate over the last 25 years, the overtly political use of the word has now been eclipsed by a more personalised use, that of describing 'personal empowerment' (a term popular in social and community work). This is seen as a process by which people gain the confidence to make decisions about their own life and act upon them, and thus discover their own power.

Increasingly, the term 'empowerment' is dropped entirely and replaced by the concept of 'building self-esteem'. An altogether more passive phrase which sees the participant as someone who needs their self-esteem raising rather than an active willing partner in the activity in question who is seeking to achieve

something. This is unfortunate, because though now somewhat discredited, the word 'empowerment' accurately describes what every arts worker knows to be one of the most powerful and direct aspects of their work - that through getting involved in participative arts work people gain skills, confidence, and assertiveness, far beyond the reaches of the original activity and that this has a very significant positive effect on communities.

This is partly as a result of simply doing an activity - any activity - with other people, and partly through the power of the Arts; through the realisation they can act, sing, paint or whatever, and that they do have a voice and words to express themselves. This is the power of participatory arts work.

It is through tapping this life-changing energy that Community Arts has the basis for making its most revolutionary claims. The combination of high profile activity, high community involvement, and high expectation that follows in the wake of Community Arts activity, is a potent cocktail, and often brings about fundamental changes to communities.

The knock-on effects can have huge benefits for communities as people start to plan more activities. Not only do communities become more vibrant, bristling with cultural activities, but people become skilled in acquiring resources, used to being listened to, and most importantly, accustomed to using creative approaches in the solving of difficult problems.

Integral to the Community Arts process is that people are not only involved in the art form itself, but in the creative decisions, practical arrangements and the management of projects. Through being listened to, through engaging in discussion and through making decisions, they begin to become accustomed to the exercise of power and democracy.

It is in the practicalities of doing projects that people often have their most empowering experiences, and it is through using these skills, and this confidence and enthusiasm in other fields, that communities begin to change. People start to take action, ranging from voicing their concerns on the parent liaison body of the local

school, through to attending council consultation forums. Often people who previously did not realise they had a voice, find out that they have the power to influence real change.

The argument goes full circle. Participatory arts projects can be empowering for individuals, but the simple fact of empowerment is not enough to ensure change in communities. A rigorous, democratic and sustained approach to Community Arts activity provides the basis for a positive change to occur and the opportunity to keep things changing.

Part two of this chapter explores the empowering effect of Community Arts in one community in Walsall - on the Beechdale Estate.

Community Arts and Empowerment on the Beechdale Estate

by Jonathan Herbert

> *"I never believed that I could sing, before somebody persuaded me to join Beechdale Gospel Choir. Now I'm singing four part harmony, it's unbelievable, I'm regularly singing in public now. I can't believe it!"*

So says Liz Whitehouse, Beechdale resident, mother and member of Beechdale Arts Forum. Through the process of Community Arts, the community of Beechdale has found its voice. Many people's voices have been heard for the first time through the medium of the Arts. There is a new confidence in self, in the community, and belief in collective action.

> *"Beechdale is a large post-war council estate on the outskirts of Walsall, with high rates of unemployment, with most working people on low wages, a high incidence of one parent families and much vandalism and juvenile crime".*

This introduces many of the Beechdale Arts Forum's applications to funders. The estate presents itself to the visitor as grey and colourless, with many boarded-up houses and shops, together with numerous public buildings covered in graffiti and racist slogans.

The estate is geographically on an island boxed in to the West by the M6, East by the A34, North by a canal and the South by the derelict site of an old power station. This leads to a sense of isolation from the town of Walsall and from the world as a whole. For many years the estate has been portrayed by the media as bleak and socially deprived - 'a sink estate' or the 'troubled Beechdale Estate'.

One of the aims of the Beechdale Arts Forum (B.A.F.) has been to challenge the negative media stereotype and allow the creative voice of the people of Beechdale to be heard. *"To celebrate all that is good and positive about life on the Beechdale Estate."*
(The aims of B.A.F.)

Through participation in arts projects, numerous people have been forced to challenge their own often negative self-image and sometimes low self-esteem, and also the way, locally, that people are written off as useless because they happen to live on Beechdale.

The Arts Forum has enjoyed huge success in discovering and showcasing latent local talent, lurking below the surface on Beechdale. Now, the papers are full of stories and photographs about Beechdale, all celebrating the Forum's latest success, be it a show, a mosaic or a carnival.

In 1990 a local M.P. laughed in disbelief when he heard about a proposed Arts Festival on the Beechdale Estate. *"What, on Beechdale? Never"*, he said. We proved him wrong. Six years on, another M.P. is issuing press releases, keen to endorse and support Beechdale Arts Forum's £250,000 bid to the National Lottery. We proved the first M.P. wrong, and we did it ourselves.

Over the past six years numerous projects have happened - all planned and managed by local people with support and supervision from the Walsall Metropolitan Borough Council Community Arts Team. These include five week-long Arts Festivals, three major Community Plays, three Winter Lantern Processions, a Youth Theatre, a Gospel Choir, numerous Variety Shows, a Writers' Workshop, Banner Making, Mosaic Work, Video Work, Music Workshops and others. On Beechdale there is now an annual calendar of events, which people look forward to and which continues to involve new participants.

The power of creativity

"Why has the Arts Forum been so successful?" we are sometimes asked, and the answer lies both in the power of the Arts to bring about change, harnessed to the principles of empowerment of

local people and their complete ownership of projects. Undoubtedly for many individuals, the Arts have also been transformative. The power of creativity has opened up new possibilities for people and has greatly extended their vision of themselves and the world they live in.

"I felt prouder when they clapped", said a small ten-year-old boy. To be clapped by two hundred people at the end of the show, by members of your own community, is a highly charged and powerful affirming experience. To grow in confidence, to get up on stage after weeks of painstaking, painful, doubt-ridden rehearsal is a powerful achievement. To be told that you are a success and be really praised has been a new experience for many in our Forum.

People have physically glowed while on stage and have come alive in new and exiting ways. To hear a sixty-eight-year-old man read his own work in public for the first time is powerful, inspiring and dynamic for both the author and the audience. To have taken part in sewing a banner or creating a mosaic, is for many their way of contributing and participating in something original and new. It is in stark contrast to sitting on a production line being told what to do, doing the same job every day.

Life-changing decisions have been made sitting round and chatting, sewing up a costume or creating a set. A women decides to leave her violent partner, somebody else is encouraged to apply to go to college, whilst another gains the confidence to go out and get a job.

"Loads of people have been involved ... It's something new and worthwhile and is a central topic of conversation on the estate. It's bringing us together and is giving us something to think about for ourselves, rather than having other people think for us".

Underlying the Arts Forum's work is the principle of local planning, control, management and evaluation of projects. This has meant that only projects and art forms which are appropriate are used on the estate, and also that employed arts workers receive a lot of support, encouragement and direction. Work is always

evaluated, and above all, when a piece of work finishes, it is celebrated. Built into the Code of Practice of the Beechdale Arts Forum is the method 'evaluate, celebrate, plan next project'! To be part of a purposeful enthusiastic planning group has also been empowering for individuals - learning new skills in documentation, liaising with the media *("I've been on the radio - I'm famous!")* budgeting, planning, evaluating ...

Vital to Beechdale's success has been the partnership with Walsall M.B.C. Community Arts Team who have provided training and consultation in managing projects and workers in a way that has empowered local people. This has meant that freelance arts workers of the highest calibre, highly committed to empowerment, have been employed.

Where arts workers have been too dictatorial or have been lacking in 'people skills', they have soon been discarded. Thus local control has meant appropriate artists being chosen, alongside appropriate art forms and visions, and the dreams and aspirations of local people being acted out. People begin to use voices they never had before.

Above all, to have control over things happening locally, rather than 'them' doing it for us, has been a transformative and highly politicising experience for many. Making history rather than letting the world go by. As Gary Preston says:

> *"It's the first time I've done anything like this and I'm over the moon. It beats sitting in front of the telly and falling asleep by 10 every night. I've learnt about expressing myself and joining in with everyone, about being a doer rather than a watcher. It's given me a purpose in life, made me part of something special and given me something to look forward to."*

The Forum has also begun to open people's eyes to the wider world. Last year fifty people from Beechdale visited the Royal Opera House in Covent Garden, London, to see Verdi's *'Otello'* and this year a Gospel Choir from Beechdale has sung in Lichfield Cathedral.

"Hey look, the mosaic's up, I made that!", shouted eleven-year-old Carry. It had been the culmination of four months' work, designed and installed by local people with expertise and skills passed on by two local arts workers. The project had involved over one hundred and fifty local residents of all ages. A central principle of Community Arts is access to all, and part of Beechdale's success has been in encouraging a broad cross-section of people of different ages and abilities to work together.

On an estate where young and old are pitted against each other, where the elderly live in fear of gangs of youths, and young people are verbally abused and denied access to public buildings and play areas, the Forum has sought to break down these barriers. The new pride which people feel in Beechdale and its artistic achievements, is shared amongst young and old alike. Through learning to trust and work together, young and old alike have gained a new respect for one another.

Beechdale now has an annual timetable of artistic events throughout the year, and plays, festivals, processions and projects have become both a focus for community and celebrations of a new positive sense of identity and belonging. The Winter Lantern procession last December involved over two hundred lanterns, and the streets which people were afraid to walk at night, were reclaimed as hundreds of people came out of their houses to watch and applaud the procession.

As well as celebrating and encouraging community, the Arts on Beechdale have allowed people to explore many issues. Racism has been confronted and challenged through our working practices; through drama, writing, work in schools and by employing a number of black workers on an estate with traditional support for the National Front. Domestic violence has been confronted again in drama and through 'making' projects, which have allowed women to begin to talk of their experiences for the first time.

Bullying has also been a constantly recurring theme, as has vandalism, juvenile crime and anti-social behaviour. The Arts Forum has run projects with young people at risk, and those who

have participated have begun to feel less isolated and that they belong somewhere.

But why has Beechdale Arts Forum worked? Why has it become so successful when so many other projects over the years sponsored by Walsall City Challenge, by Central Government and by local authority initiatives, have failed? B.A.F. has succeeded, I believe, for two main reasons. Firstly, because arts projects are fun, and secondly, because of the principles of Community Arts - of access to all, local control, empowerment, participation and of partnership.

Because projects are fun, people participate and are not scared to have a go. Many of our participants try something as a 'one-off' and are hooked, something captures their imagination. The Arts also provide people with new confidence, a vision of something new. To dress up is to be taken out of yourself, and opens up new windows of consciousness. To make and create something with a group, gives you an enormous sense of achievement and can change how you look at things.

It is very hard to quantify community spirit and how the Arts build this and empower a whole estate, but to see the colours, lights, costumes, to hear the beat and voices of the procession, is to experience a very powerful sense of common identity. The procession is soon gone, the carnival over, but the shared collective memories live on in the conscious and unconscious mind.

"We've found a world where we can live together, We've found a world that was here all the time.

"When we cleared the soil so it could breathe, and dug away the grime, We found a whole new world called common ground."

(*'Don't make me Loff'*, Beechdale Summer Panto, 1996)

Chapter three

Whose Voice?

Keynote: Participation

Participation is a concept intrinsically tied to Community Arts. Indeed the term 'Participatory Arts' is often used interchangeably with Community Arts. It is a word that evokes images of active involvement. People getting involved, doing things, being practical. As a concept, it reaches to the very heart of the values that underpin the movement as a whole. It is, however, also a concept that has been 'officially' adopted as a universal panacea.

Managers now seek the participation of staff in making decisions, schools involve parents in the classroom and councils involve communities in local initiatives. It is, therefore, important to unpick some of the issues underlying the use of the word to gain a clear understanding of its meaning in Community Arts terms.

So, what is it that makes participation in the Arts different from participation in a game of Monopoly? The first thing to point out is that the use of the word 'participation' these days refers to more than just a description of the act of taking part, it has both a philosophic and a political dimension as well. Its use implies a belief in the unrepresentative nature of institutions. That is, that spheres of life, be they government, management, or even the Arts do not automatically act in the interests of the wider community, and that participation by the recipients, or users of the service, can change the way in which these institutions function to make them more representative and more effective.

In relation to the Arts, therefore, participation refers to the significance of involving people who would not normally engage in the Arts. It is used to advocate an approach which promotes greater access to the Arts in general, and more specifically, involvement in the processes which define the Arts.

In this way:

- Arts institutions will become more representative of the wider community, more accessible and more relevant, addressing concerns and issues that represent many cultural voices,

- the distinction between creators and audiences will break down, challenging the way culture is made, interpreted and valued.

Unfortunately, there is a problem. The reason why the concept of participation is so popular is because it is an approach that gives the appearance of the sharing of power without the necessity of actually changing anything. Many institutions, better able to see the advantages of being seen to give up power rather than actually giving up power, have thus seized on participation as a very effective tool of legitimation. For, if it is possible to co-opt people into the processes and activities that exist to either oppress them or to serve the interests of the powerful, then it will reduce any impetus for change. Participation becomes an effective method to preserve the status quo rather than to challenge it. This, to a large extent, explains why the whole world is in on the act, and it is no surprise that participation has been used in the same way to legitimise the Arts 'world order'.

Orchestras now have community outreach programmes, theatres run workshops for community groups, and museums have culturally specific programming whilst running workshops in various media. This is, of course, generally to be welcomed. Anything which aims to demystify the Arts and to bring people closer to the creative process is something to be applauded. It does not, however, necessarily change or challenge anything.

Community Arts 'set up shop' because the closed doors of the elitist Arts establishment stayed closed. Since then, Community Arts methods have had a tremendous impact on the way the Arts establishment views itself and the way it functions. It remains true, however, that these efforts on its behalf have been done more to legitimise than to democratise its activities. It still largely behaves as if it has a monopoly on defining culture and promotes a version of the Arts based on the interests of its own professional elite.

Community Arts offers an alternative view - that the Arts can be a broad-based activity available to everyone. People, given the chance to make art collectively, in a way that is self-affirming, empowering and democratic, can take back the means to create their own culture. It is an approach which bypasses the Arts establishment and while welcoming moves by the establishment to change, does not depend on this change.

Cultural democracy

This approach has been given different names over the years. Probably the most popular is 'cultural democracy'. This concept defines both an approach to the Arts and an outcome. A culturally democratic approach is one which promotes the Arts in a way that is accessible, where all contributions are valued, and where everyone has an opportunity to take part. The potential outcome would be a society which was a cultural democracy. This would be a democracy in the real sense of the word, full of discussion, action and vibrancy. A culture made up of many voices, defined by and representing all cultures and communities. It would not exclude professional artists but nor would it value their contribution over any other.

This, then, is the driving concept that explains the way in which many Community Arts organisations organise their work. It defines the aims and objectives, and the methods, the working practices and outcomes. This is why Community Arts projects:

- are developed with people who have little access to the Arts
- promote creative involvement at every level
- involve people in the decision-making process
- value everybody's contribution
- start from a place where people are
- aim to meet people's needs
- prioritise the shift in power from the artist, or arts worker, to the group through the passing on of skills and understanding.

Despite this seeming clarity of vision, Community Arts has not completely managed to avoid the accusation that it, too, is in the legitimation game. This is largely because it does not exist independently of the need to pay for its activities. Of course, this

is not news. Artists have always had to flatter the prejudices and interests of their patrons. It is partly because Community Arts strives to embrace such a wide diversity of issues and actively seeks to make connections, that it has succeeded in diversifying its funding base over the last twenty years of economic stringency.

On the positive side, this has brought new money to the Arts and convinced a lot of organisations of the value of Community Arts activity in promoting their own aims. Town planners now work with community artists to involve local communities in the development of new initiatives. Artists work with patients in a wide variety of health settings to consult them about issues of health and health care.

In youth clubs, day centres, and community centres throughout Europe, participatory arts are being used to involve groups and communities in creative activity to voice their concerns or opinions about a wide number of issues. More perversely, Community Arts methods have been harnessed to provide diversionary activity in a wide range of settings from probation centres, to prisons, in the belief that the Arts have the power to rehabilitate and reform.

From the Arts Council itself through to local councils, Urban Renewal, Regeneration and the National Health Service, a whole host of institutions have advocated or used participative arts methods (and Community Arts organisations) to involve communities in their agendas, because it has proved to be an effective method of promoting committed and high quality involvement by the participants.

In many ways, therefore, the most important shaping factor of the Community Arts movement has been the financial environment, and despite its claims to be a movement responding to the needs of its participants, it is a movement that is funding-led as much as it is needs-driven.

This does not mean that Community Arts methods are fundamentally compromised, but it does highlight the need for rigorous self-evaluation, and question its claims to be a subversive activity. For if Community Arts exists to promote participation, how far are its claims discredited by the need to go to funders?

Do their agendas pull in different directions, or seek people's participation in order to legitimise their own activities?

This issue provides the basis for the second half of this chapter and the backdrop (and lighting effects) for the rest of the book.

Varied Ability Arts

by Maxwell Bailey

Introduction

"Everyone has abilities and everyone can make the most of their abilities."

In Walsall's Community Arts Team the above phrase describes the driving force behind the work of our varied ability arts project work with disabled people; people whose voices are underrepresented in national and local political and social debates.

Arts and Disability was launched in Walsall in 1998 with a steering group made of disabled people and disability organisations. A programme of projects were developed that worked within day centres and disability organisations across the Borough. Later this work spread out into community and social settings.

Varied ability projects are functional arts projects in which people do things together, whether the aim is to make a first movie, or to build a website or letting everyone know about a group's issues. There are always clearly identifiable aims, objectives, processes, products and outcomes in our project work. These are recorded, discussed and agreed by all involved before a project starts, during the process and after it has concluded.

Participation

"As a variably able person I integrate for some activities, do some things differently and recognise that there are things I can't do well enough to give me satisfaction and some things I can't do at all.., That's the same for all of us."
 Kevin Carey, *Ability* Magazine

There are many difficulties around setting up arts activities for disabled people. The barriers are man-made; either from within or from without. Varied ability arts projects and the participation in them, is about the removal of the obstacles that society has constructed in the built - engineered - institutional - social world, that prohibit access and participation to the Arts for varied ability people.

Community Arts practice improves opportunities to access activities that people have previously not been able to take part in. Participation in arts activities is a part of the process that leads towards greater access to other activities. In short, involving people in creative projects and enabling them to stay involved all the way through, makes a demonstrable change in people's lives. People with varied ability are no exception. In striving to improve the quality of creative arts activities for people with profound disabilities, the team recognised that there was a need to provide more inclusive projects and truly accessible creative arts environments for people with wide and varying ability.

"It is amazing what happens when you introduce the Arts. Boundaries are broken down and people make huge strides."
Michael Richardson, *Mosaic Arts*

If the physical obstacles to getting into venues and taking part in activities are removed it does not necessarily follow that varied ability people will be able to participate in arts projects. People need encouragement and need to feel safe. Without experienced art project managers, development workers, arts workers, support workers, personal assistants, signers and guides; projects with varied ability people will run into difficulties. Delivering a successful project requires a core team of people, with different but complimentary skills, who have forward vision and a commitment to work creatively together.

Partnership with Social Services

Social Services have been working in partnership with community arts to maximise the use of their resources and opportunities for varied ability people and staff. Without a mutualy agreed partner-

ship with Social Services, the work with varied ability people would be very difficult, if not impossible, to deliver.

For the first two years of the work, two experienced care workers from adult day centres were on part time secondment to the Community Arts team to support the Arts work programme. The secondment provided a joined-up approach to problem solving the removal of the barriers to acess. The benefits were:

1. The seconded workers got experience of developing and co-ordinating creative arts projects, and inspired by their new knowledge and experiences the secondees took new skills and new ways of working, back into Social Services.

2. Community Arts workers gained invaluable knowledge of how to make it happen in social services settings.

3. Community Arts workers gained experience in understanding care for groups and individuals.

The net result was that the day centre service users now have support staff within the centres who develop, set up, deliver and evaluate quality events and activities, knowledge of which can be transferred to a broader working field with people of varied ability.

Other Walsall services providers and national agencies have also supported projects to enable greater access including: New Art Gallery Walsall, Walsall Libraries, the Walsall teaching Primary Care Trust (tPCT), Arts Council West Midlands, Arts Council England, National and West Midlands Disability Arts Forums, DfES New Opportunities Fund and the Black Country Knowledge Society, Equal and the Arts Council Lottery Programme.

The physical problems - transport and venues

Walsall mirrors the national situation around public transport and transport networks for those without their own car. It needs investment. Transport still has unusable access points for varied ability people. Without appropriate transport that meets the needs of varied ability people you cannot provide a successful arts event or session. The situation will not change until links are made between taxi, rail, coach and bus networks with a booking system

that disabled people can operate and navigate from their own homes or group centres. Walsall Community Arts use Social Services adapted vehicles. Early Walsall experiences of inflexible institutionalisation in the transport arrangements led to transport arriving early and leaving arts workers with three people left in a session, and seventeen people going early because the driver had to get people back to the centre before getting them home. Not good for the arts worker and worse for the participants. Once the transport people were made aware of the consequences of their system and through much discussion, we found a way to change the transport arrangements. It was not deliberate, they only did it that way because that was the way they had always done it!

Many public and some privately owned buildings are now equipped with ramps. Some have built-in support for varied sensory ability but very few have a stage with a ramp, adaptable and accessible theatre seating, adequate toilet facilities that have a hoist and are wide enough for an electric chair. Hardly any have a room with a bed for health care. Varied ability arts projects need pleasant environments that are welcoming and friendly. Varied ability arts project workers have got a reputation for going around Walsall's venues and looking at the toilets before booking! We make sure our varied ability participants get the very best venues and we spend our money with the places that give us what we want.

Debate, decision making and democracy

We have moved away from the dark ages when institutions evolved a manageable pattern of providing time-filling routines and were essentially, containing people. Nowadays, independent living for disabled people has increased and maximised the ability of individuals to live independently. More importantly, disabled people have gained the opportunity to contribute towards and enrich, mainstream culture. Disabled people can choose to work with the Community Arts Team through a variety of routes.

The team provides:

- an advisory service that gives practical help with setting up and developing ideas,

- a website and publications that inform local people on project developments,
- development workers who work in the community to contact and work with groups to seek opportunities for projects.

The team undertakes:

- presentations about the teams work to local groups and organisations,
- press and campaigns that enable local people to find out about the work of the team and developing projects.

Decision-making depends on a shift of power on many levels in an organisation and in all people's minds. The Community Arts Team has been working to secure a post for a person from within Social Services to take a lead on varied ability arts projects. Making decisions in varied ability work is encouraged by the Community Arts Team by setting up steering groups and forums. We offer practical advice and experience when there are decisions to be made by new and developing groups. A steering group of mainly non-disabled people who used to make the decisions for varied ability people in Walsall, has been replaced by a forum run by and for disabled people.

Extensive consultation underpins project work, undertaken using presentations showing examples of previous projects and offering a menu of opportunities. This usually results in 'taster' sessions, followed by a 'main course' project and then a 'banquet'; often a showcase event. With seconded care workers on the team we are able to consult with everyone involved using a variety of visual and personal presentations adapted to meet group and individual communication needs.

This consultation process must acknowledge that each individual has an awareness and understanding of the choices being offered. This may involve working with those closely involved with the participant to help in the recognition of the individual's needs. To be able to involve people with severe learning disabilities, for example, consultation has to be tailored appropriately. It is

amazing what people with the most profound disabilities are able to tell you if you frame the question correctly.

Varied ability arts projects

"Arts are always seen as an add-on. This is wrong, they should be part of the culture of the organisation. People of varied abilities should be noticed as artists, they should be out there – in your face."
Richard Devlin, Resource Manager
Walsall Services Learning Disabilities

Varied ability arts projects have pushed the work of the team into new and exciting territory. *The Ramp* is a good example. The team at first worked with varied ability people from all over Walsall to create an event of varied ability arts work that culminated in the generation of a focus group that looked at the question; 'Why are the Arts successful in engaging people with disabilities?'

This opened up a debate on how far initiatives can be developed to bring arts and disability into the mainstream, dismantling the barriers, tackling prejudices and getting disabled people's voices heard. One of the disability groups involved used the growing debate as a training opportunity for their staff. Another group decided that they would develop disability led evening activities in Walsall on the evidence that all present recognised that people wanted more opportunities to participate in after the 6pm shutdown.

The Ramp

This was, initially, a website project that documented varied ability arts projects in Walsall. Fourteen arts workers, using differing art forms provided arts sessions with groups on different projects at different locations around Walsall. Web designer Linda Ashford and various photographers documented the achievements, ideas and aspirations of the different groups and individuals.

The management of *The Ramp* website was developed through sessions with an evolving disability technology group who quickly absorbed the arts workers website building skills and were able to upload site information. The project enabled disabled people to access ICT and provided a virtual forum for people to share experiences of arts and disability. The project also provided technology equipment and software that the groups had previously not accessed.

The Ramp was the first arts and disability website in the country that existed for people with disabilities that did not have a commercial angle and sought to highlight local issues, interests and arts activities. Then came...

The Rampant Tour
This project has provided two hundred arts activities in Walsall, involving over two thousand people, able and variedly able. The aim of *The Rampant Tour* was to get disabled people together and celebrate their lives through the Arts, taking on transport and venue problems simultaneously! *The Rampant Tour* sought to provide arts opportunities for disabled people in new community settings. The work changed disabled people's and everyone else's level of identification and involvement within their own communities.

Then we created...

The Rampant Tour Showcase

A week long festival that blended serious fun with serious work for the three hundred people who took part. Sessions included bhangra dance, discussion forums, performances, technology workshops, training and mentoring sessions, and very importantly, places to meet.

The Ramp, Rampant Tour and its *Showcase* were documented, and vast digital images of the work were projected on the outside of New Art Gallery in Walsall, clearly visible for miles around, showing the wider community that people with disabilities are fully able to do positive and creative things. The sense of pride in local disabled people's faces and voices, in seeing and knowing that their work was available for all to see on Walsall's most

famous building, has had a long lasting affect on their sense of achievement and on those who helped make it happen.

Transformation

"I don't need to make a political statement about disability when I write music, anyone can see I am disabled just by looking at me. Everyone whether disabled or not can relate to music and that is what it is all about."
Mike Taylor, musician/songwriter/performer.

Community Arts projects in any setting develop ways of establishing relationships between people on equal terms. Varied ability projects let the able-bodied see a broader picture of those individual varied ability participants. New skills and understandings emerge during the course of a project. Arts projects open up depth in peoples' characters, allowing friends, personal assistants and carers to learn more about that individual. A greater insight is gained into that person's needs by taking part, developing often through laughter, sometimes through tears, equal communication.

When I met Lee, a care worker at Shepwell Green Day Centre, she was providing arts sessions, and much more, to adults with learning difficulties. When I mentioned computers as a way of involving varied ability people in arts work, Lee was phased. Lee told me that in no uncertain terms, *"I down' use 'em, me an computas down' get on"*.

But Lee entered a pilot Community Arts digital arts project for people at the centre. She worked with a graphic designer, a host of laptops, digital cameras and a photographer. In the course of a few sessions, Lee was so inspired with how the people at the centre were not only producing digital work but were engaging in the process, that she announced to the Learning Disabilities Resource Manager that, *"We should 'ave some of these"*, and so we went out and bought her her own 'computa'.

Lee was later seconded to the Community Arts Team. The unexpected comes out of us all when we try something new.

Conclusion

Historically we have come from a position where, if a person had physical, learning, mental, sensory or any other disability, the person was defined by a sense of 'otherness' and this otherness had social consequences when it came to inclusive participation. Community Arts work has enabled varied ability people in Walsall to contribute towards and participate in important national debates around disability issues, and begin to address the balance.

Through a sustained programme of work over a period of four years varied ability arts projects in Walsall have opened up new and challenging experiences for many people with disabilities. The project work has unlocked and nurtured latent talent, enabled people to become artists, given all a sense of pride and dignity. It has given people fun opportunities and the experience of taking part, and of being asked their opinion, of others wanting to know about them. It has positively affected their lives.

Four years on, many involved with people with disabilities in Walsall are asking; 'How can we get more involved in varied ability arts projects?' Artists and aspiring artists with disabilities, people with disabilities, carers, service providers, and associated professionals are all contributing towards solving disability issues through engaging the Arts.

Reference

Kevin Carey, 'Now you see me now you don't', *Ability* Magazine, 2001, edition 35.

Chapter four

Take a Deep Breath

Keynote: Access

For whom? To what? With what?

Community Arts takes on a broad agenda when it comes to the question of access, focusing on the whole range of processes at work which prevent people not only from taking part in the Arts, but also from being involved in the processes which define their cultural identities.

Community Arts is about providing access to the Arts in a positive, practical way. Community Arts prioritises work with people who are not culturally represented, and who, through the mechanisms that produce economic inequality and social disadvantage, have few opportunities to participate in the Arts. These are the people whose voices are seldom heard, and almost never listened to.

It is an agenda that is partly political, about righting injustice and inequality, and partly practical, where, given that we have limited resources, where will we make the greatest difference? This approach has given rise to much criticism over the years. From accusations that Community Arts is really just a type of arts-based social work, through to charges that by narrowing its horizons so much, it actually ignores many other groups whose opportunities are limited. There is, of course, some substance in both these criticisms. But the truth is, that really Community Arts is as pragmatic as it is idealistic, and as opportunistic as it is premeditated. It does not function in a scientific way, but applies methods tailored to the specific needs of a given situation.

Access for whom?

Community Arts always talks about working with groups. This may either be in reference to a social grouping such as the

unemployed or youth, or an actual group like a youth club or members of a drop-in centre. And, although we refer to groups as if they were fixed entities, the reality is that most groups who take part in arts projects are not fixed at all but are constantly changing. Such is the nature of our work that although a project may be focused in terms of the people we want to take part, the actual group membership may be small and in flux.

We constantly work for the 'knock-on' or secondary effect. For example, a project may aim to benefit a whole housing estate but in reality involve only thirty people in actually doing hands-on art work. This is not a problem. If those thirty people have a good time they will tell their friends and there will be more next time. Only thirty people may be involved in the project but two hundred may come to the opening. Others may be involved in making sandwiches, giving lifts or opening the doors of the community centre at the right time. Skills learnt on a project stay in the community to be re-used and passed on, and more importantly, people who have been inspired by being involved in a project will be keen to work with you again to ensure there are more projects.

Success breeds success. Funders are always keen to fund future projects if you can show that past projects achieved their aims and objectives. The trick is always to be realistic. The idea of the secondary effect dictates a long term view of accessibility and provides another argument in favour of a developmental view of our work. So who are these groups, and how do we decide exactly who to work with on any given project?

Community Arts work prioritises work with groups who, through social or economic disadvantage, do not have access to the Arts. Depending on the focus of the project and whose access you aim to prioritise, groups are usually defined according to one of the following criteria:

- **Geography;** a housing estate, a street, a block of flats ...

- **Social or cultural groups;** African Caribbean people, Asian people, young people, people with disabilities, the unemployed ...

- **Issue;** people who share a concern and want to use the Arts to explore and express that concern

- **Art form;** people interested in participating in the same activity.

Usually a combination of these factors will determine why the group has come together and why they want to work on a project.

One factor may be chosen as the most important. The group may be an existing group, a group of young people who get together for social reasons and who would not mind having a go at anything provided it is fun. Another group may be one who has a burning desire to be involved in a particular art form and to whom the other reasons for coming together are less important. As practitioners it is our responsibility to keep the issues in sight and to be clear why we are working with which group on what project.

Access to what?

To the Arts, yes, of course ... but how to choose the art form? The scale of the project? Which arts workers? It is one of these 'chicken and egg' arguments. Without experience, how can people make choices about what they want to do? And yet if the art form is previously decided how can the process of choosing the project's art form be democratic?

In working with groups who have little or no access to the arts, representatives who speak on behalf of groups can easily make ill-informed choices. Either having a fixed idea about art form - *"Yes, I'm absolutely certain that everyone in the youth club wants to paint a mural on that unsightly wall that needs decorating"* - or no idea at all - *"The Arts? No love, no-one's interested in that kind of thing around here."*

Community Arts workers have, therefore, out of necessity adopted a series of methods and working practices to ensure that projects are both accessible and tailored to participants' needs.

Arts detective work

Usually, long before any decisions are made about art forms, arts detective work will be taking place. This involves getting to know

your patch, dropping in on as many community centres as possible, talking to as many key people as practicable (over the inevitable cup of tea), finding out key issues, local problems, local events ... In this way a picture of what people do, think, say emerges. This process, often called *networking*, enables the worker to make some hunches and to try out some ideas.

The Arts connection

Initial project work will often be small-scale, linked to existing interests, activities or issues. Perhaps the over-sixties' luncheon club may like to try a bit of creative writing while waiting for lunch to be served? Has the tenants' association thought of using video to strengthen their campaign for housing repairs? It may include taster workshops in different art forms or link in to existing skills. Retired leather workers in Darlaston (near Walsall) enthusiastically participated in a project making large scale banners because they could use the skills they had spent their whole life developing.

Once the *Arts connection* is made, it becomes easier to engage in discussion about the kinds of art forms and the kinds of projects that should be developed. It is, however, important to keep an eye on the forums available for the discussion to take place.

Keeping it accessible

Project steering groups and local forums can be very effective ways of encouraging participation in the decision-making process. They can also lock the debate. The tendency is always to repeat the successful formula. The community pantomime steering group will always want another pantomime, usually with the same arts workers and the same community groups.

Community Arts exists to broaden out activity and to provide new opportunities. This can happen only if the door is always kept open to new ideas and new possibilities. This does not mean forgetting the old groups but it might mean targeting some new groups for some taster workshops next time or 'piggy backing' a new activity on the back of a tried and tested formula. For example, perhaps it is possible to attach a dance worker to the

community pantomime this year, and if the participants enjoy the experience, a dance project could happen in its own right once the project is over.

The key to increasing the accessibility of the Arts is to make them relevant, welcoming and within reach. This means to a large extent keeping them local and keeping them on-going. It is no good talking to people about the kind of arts projects they would like to see if the last time a project took place was two years ago, or there is no chance that anything can happen for the foreseeable future.

The key question, therefore, is once communities have been accessed to the Arts how do they access the relevant sevices and resources to keep things going? The second part of this chapter drops in on a 'conversation' between members of the current team at Walsall about their skills and about what is special about the way they organise themselves that provides local people sustained access to the arts.

Community Arts Development Workers: Agents for Change

by Glen Buglass with Rachel Parker, Jan Robinson and Claire Taylor

Community Arts is all about people taking part in creative activities and the facilitator for this participation in Walsall is usually one of the Community Arts Team's Community Arts Development Workers. The role of the Community Arts Development Worker is to find out what people want to do and provide the relevant skills to be the enabler for their wishes to become reality. Rachel Parker explains:

> *"A Community Arts Team Development Worker's job is many things. It's always challenging, creative, inspirational, supporting and very rewarding. The role continually grows and develops and the job constantly adapts to circumstances. The role of the development worker can vary greatly being advisor, fund-raiser, consultation leader, facilitator and innovator - sometimes all at once. The focus and the driving force behind the work remains firmly rooted in working to improve the quality of life of people we work with. We do this by listening to people and addressing local needs and through working collaboratively across the Borough in partnership with many people, in many settings and in many ways. As arts development workers, we are the agents that facilitate change, for an individual, group or community and as a result our work has informed strategic developments and decisions."*

Claire Taylor adds:

> *"To be a Community Arts Development Worker you need to be a good negotiator on all levels and be able to spot potential problems. You need to be a logistical thinker, be able to manage people, be creative and flexible, be able to think and plan ahead. You need to be the caretaker for the*

groups of people you are working with, support other arts
workers ... Oh, and be careful of those opportunities that
seem too good to miss, but be careful of your time
management, rushed projects always throw up problems!"

Us or them?

As a team we have always been a little shy about explaining what
we do and how we do it. We have been criticised for this. There
are reasons for the apparent shyness. The job of the arts
development worker is not about attracting attention to oneself.
The people we work with are often on the edges of society, people
who do not get heard from very often. Our job is about enabling
others to take the applause.

Rachel Parker writes:

"At the heart of all participatory arts activities are local
people making decisions about project content. Through
support and consultation their opinions can be voiced, their
concerns shared, aspirations realised and by collaboratively
working together, realise their aims. Participatory arts
activities work on many levels and can provide participants
with the experience of change within themselves. New skills
are developed, confidence is raised, hidden talents are
realised; finding solutions and making decisions, all valuable
steps in the development of personal skills and individual life
journeys."

Tools of our trade

The Liverpool Institute for the Performing Arts BA (Hons) Degree
in Performing Arts Community Route looks for the following
potential qualities in prospective students wishing to undertake a
course in community arts development work:

"Performing skills, a desire to work both inside and outside formal
arts institutions, a desire to help other people express themselves
through performance who may have not done this before,
versatility and good teamwork skills, composing, improvisation,
arranging, directing, political and community awareness,
communication and management skills and entrepreneurial and
fund-raising skills." (LIPA 2001)

Compare the above with the team's development worker Claire Taylor's description of her career path:

> *"I left school at 16 to train as a hairdresser. At the time I was singing and performing with a local Punk band. Soon I went full time with the band. When the band split, I landed a job as an 'arts organiser'. I put on gigs for local bands, learnt a few things around marketing and how graphics worked. I experimented with photography. I even wrote a short play and got kids to perform it as part of the Summer Play Scheme. I helped out with an organisation called Walsall Youth Arts that had a Board with young people participating on it. I continued with singing and getting groups together, got some work facilitating women's music workshops and became the Chair of Walsall Youth Arts. When the opportunity arose I joined Walsall Community Arts Team as a project co-ordinator. I am now an Arts Development Worker."*

It is not necessary to have all the skills mentioned by LIPA, and Claire developed to expert status to be a Community Arts Development Worker, but the more skills you do have highly developed, then the better you will be at the job. Perhaps the most important skill is to have done most of the jobs you want others to do yourself and if you have not, at the very least, find out what those jobs entail. Many people in arts development work have arts-based degrees, teaching or youth qualifications and the like. Some do not.

It is a broad range of experience that makes the best arts development worker, a breadth of experience in the Arts coupled with a real desire to use the Arts as a tool to benefit other people's lives. The thing we all have in common is the sure belief that participating in the Arts brings great things to people.

A model way of working

The Community Arts movement has developed various ways of working to create and deliver arts projects, which we use where appropriate in our work in Walsall. Often people are mystified about how we achieve our results. There is no mystery really, we

employ frameworks for people to be successful in. These frameworks are described here as 'models'.

Our mainstay is our own 'participatory model'. In this way of working people are involved in decisions on all aspects of the work, from the creation of the project, the art form to be used and even the selection of the artists who are going to work on the project. The arts development worker and artists are facilitators for people's hopes and aspirations and work with them through project creation, delivery, evaluation and celebration.

But before the participatory model can flourish we usually employ a primary method, our 'neighbourhood model'. Here the arts development worker simply spends time in a community getting to know people, setting up small workshops, referred to by us as 'tasters', where people can try something out, begin to get involved and in the process dispel the ingrained belief, held by many people in many different kinds of community, that the Arts are not for them. Only then can we effectively get a larger project up and running using our participation shape.

Jan Robinson describes how the 'neighbourhood model' works in action:

> *"The job is not only to befriend, understand the local relationships, clock the hidden community leaders, know which street corner to find the teenagers on a Wednesday night but also to know which pots of money are available and which other professionals could link to the work. The neighbourhood model holds individual people and community relationships right at the heart. It is the 'stop by and have cup of tea' approach."*

The interesting thing about these two models is that they are not art form led. They lead to an art form, but are not driven by it. The development worker and local people work together to draw up what the project needs to achieve before deciding on the most appropriate art form that will deliver the results.

We use this model again and again, with communities and other partners. It is by far and away our preferred and most effective way of working. But we do use other ways of working as well.

For the Millennium celebrations we were invited to create a community play for Walsall for presentation in the Greenwich Dome. Here we were not reacting to an identified local need, but to a request for a local showcase. The way of working we adopted here and have used successfully since, was much more akin to Ann Jellicoe's Community Play Model. (Jellicoe 1987)

In short, the Community Play model is delivered by a professional theatre company that specialises in creating new, locally-based theatre on a medium to large scale. An artistic director, playwright, costumier, choreographer, musician, historian, technicians and actors from the company work with a whole town to create a play, often with a cast of hundreds, based on local stories, characters and events, to make a spectacle for all in the town to enjoy.

The historian researches the material, the playwright writes the show, the artistic director oversees the production and directs it, and the professional actors take key roles. Other roles are taken by local performers who have auditioned to be in the show. People working with the costumier make the costumes. The music, written by the musician, is performed by local music groups and other jobs in the creation and delivery of the project are managed in a similar way. Once done, the theatre company moves on to repeat the process in another town.

Our play for the Millennium, called *Our Town Story*, was created as described above and a very successful piece of theatre it was too. Jellicoe's book, *Community Plays and How to Put Them On,* is around theatre but the model could be applied to visual arts or filmmaking, for instance. This way of working, though, is art form led and an art form led Community Arts project does generate a different kind of experience to the participatory model which is needs led. Not surprisingly, the needs of the art form are met first and foremost, not necessarily the needs of the people who are in it.

There is another variation we use in Walsall. From time to time we get to work with several communities at once and we engage a way of working we have dubbed *The Gala Model*. This is a hybrid of the participation model and of the community play model. Groups work separately on their piece with their arts workers. All the ideas and work created by them are theirs, but the overall artistic vision and direction of the work is held by the artistic director who will be appointed by the project steering group to co-ordinate the creation of this often complex and always very interesting way of making a Community Arts project. Jan Robinson explains further:

> *"The gala model is used when a cross section of people work on a common theme that is developed separately and brought together for a collective sharing and celebration. The common theme may be cultural, it may be issue based, it may be art form led.*

> *"The whole picture is held together by the artistic director and the arts development worker. It is they who are responsible for the logistics of managing the finale event, usually with the support of a steering group. All the contributions to the finale are supported and devised by individuals or groups within their local settings and the quality of the experience emerges from the opportunity to look outwards, engage with new people and experience being involved at the heart of a large scale, larger than ever dreamed possible, community based event."*

We have developed projects using dance as the art form, projects with the other areas of the performing arts, film work, music productions, fire sculpture work, girls' work, writing projects, projects around civic pride, about ethnicity and celebration of all manner of different peoples and issues by using the *Gala Model*. It is a powerful tool.

The choice of which model to use is a very important decision in a Community Arts project's development. *The Gala Model* is probably not appropriate for a small community group's first foray into the Arts. Better, perhaps, to use neighbourhood in this instance. Nor is the *Community Play Model* the best thing for finding out people's concerns around a given local issue.

Participation, may be, called for here. Similarly, the participation model is not necessarily the right way to make a high profile civic performance. *Community Play* may fare better. The decision about which one to use all depends on what the group's needs are, what is wanted from the project and who is going to consume it.

The impact of development work

The impact of arts development work, its inclusive and effective ways of working, is wider than just the development of individuals in their communities. It has an effect on the delivery of other services to these people.

Rachel Parker writes:

> "*The process of Community Arts work naturally instigates change. Evaluating and learning from projects and what people say in them can highlight areas for further development. Community Arts development work has an impact on local agencies and within local authorities. Arts development work can make changes in policy, affect funding decisions and strategic decision making and new initiatives, frameworks and innovative programs of work are developed. Local priorities are set to meet consultation findings after arts project work. Links are strengthened across partner organisations and bridges between service areas are built.*"

The Walsall Community Arts Team has been around for fifteen years. The thing we have in Walsall that a community theatre company, for instance, may not have, is the ability to stay in one area for a long time. This is the main difference between Walsall arts development workers and those who work in areas where there is not a full-time team. Inevitably in this situation, workers are bought in, or 'parachuted in' to do an arts development job and leave once it had been done.

By being here for a length of time it means we are able to develop real relationships with people who live here. Arts development workers in the team have seen children grow up and have been a part of those young people's path to adulthood, encouraging the development of participative, creative and confident citizens.

Similarly, we have been part of the process by which adults take on new challenges in life, have been a part of how organisations have changed, taking on the Arts as a way to deliver its work - NACRO, the TPCT, Social Services to name but three. For us this sustainability and support given to us by a long term commitment from the Council is important and meaningful. As an integral part of the local authority we are able to effect change internally. By being here, we can make sure local people's voices get heard.

References:

Jellicoe, A. (1987) *Community Plays and How to Put Them On,* London: Methuen.

Liverpool Institute for the Performing Arts (2001), 'BA (Hons) Degree in Performing Arts Community Route', Liverpool.

Chapter five

Who is Listening?

Keynote: Quality

The widespread perception still persists in many corners of the Arts establishment that Community Arts is in fact bad art. While there may be a grudging or even welcome acknowledgement by the great and the good of the need to widen access to the Arts, especially when this leads to larger more diverse audiences for their products, underneath the gloss, most of what goes on is lip service.

The truth is, that the bastions of the Arts world and most of its institutions do not recognise the products of collective Community Arts activity as 'real' art, that is, something which is as valid as those which they, the establishment, produce. Community Arts is simply viewed as some kind of arts-based social work that occasionally throws up the odd talented individual who may be allowed access into the temple's hallowed corridors.

So, how has this come about?

In some ways it is not surprising that this attitude exists, since Community Arts threatens the very basis of the élite's reason for existence. After all, the only justification for their position is that they are in some way special, talented and skilled, and that what they produce, show or make, is only possible in the realms of a professionalised arts world.

This is, however, not the whole story. The problem has arisen partly as a result of the failure of the Community Arts movement to engage in any real discussion about the nature of 'quality' in the field of artistic endeavour, and as a result, the movement has allowed its products to become peripherised and down-graded.

Process versus product

The problem lies to some extent with philosophy, and more specifically, with the debate that has grown up about which should have primacy, process or product; should the quality of experience in producing a piece of art, take precedence over the quality of the products produced? While looking for models of collective action and interaction, Community Arts work was itself greatly influenced by youth and community work practice which tends to prioritise process over product. In this approach, work focuses on bringing people together to look at issues, share experiences, and to have a sense of collective spirit - in many ways the activity which brings them together is of secondary importance; a means, rather than an end in itself.

This model was always inappropriate to explain any process involving the Arts. The product is always important if only to the creator. The quality takes on an even greater significance if there is an audience, especially if the audience is larger than the immediate peer group.

If the artistic process is to be empowering then people cannot be set up to fail. It is no good inviting people to be involved in projects on the basis of unrealistic expectations about the quality and nature of the finished product. Some art workers and art organisations have avoided this issue by making sure that everything they produce with groups is of a standard comparable with professional products. While this may be possible in some art forms without compromising the process, this work practice sidesteps the issue. In reality, this approach is only possible if you exclude some participants on the grounds of skill, or the artist takes such control of the process that the finished product is largely theirs.

Community Arts workers operating in a democratic way must face up to those issues and be assertive:

- If the process is to be democratic, the level of people's skills cannot be a determining factor for involvement.

• Whose project is it anyway? If the arts worker takes full control of the final product, the community ends up helping out on his or her project - not the other way round.

What is necessary is that, while striving to attain the highest possible standards, we need to be clear about what we mean by 'quality' when communicating with the funders, the communities we work with, and to ourselves. It is no good standing up for low quality arts products or hiding behind the smoke screen of the process versus product argument. At the same time we cannot simply let the 'ivory towers' of the arts world have it all their own way when it comes to defining the nature of quality.

On the issue of quality, Community Arts work gives rise to some fundamental questions:

a. Context
Is there a fundamental difference between arts products which spring from a Community Arts project and those that are produced by the commercial or 'high' arts?

b. Authorship
Who is ultimately responsible for the finished work? The professional arts worker or the community?

c. Audience
What should the relationship be between the finished work and its audience? Do Community Arts projects need an audience at all? Should they just be an audience of peers? Can they have a wider audience without carrying some sort of government health warning about the quality?

There are no set answers to these questions and I would argue that in essence the actual answers are less important than the debate. To help us in our discussion, Community Arts has three essential principles;

(i) that given the right context, approach and resources, Community Arts can produce better more appropriate products than any other method,

(ii) that any debate should involve the voice of all participants and not primarily that of the professionals,

(iii) that Community Arts is essentially a completely different way
of looking at the world.

In many ways communities are their own harshest critics. If they
do not participate in something which they perceive to be of high
quality they could well be lost to the Arts for good. The important
thing is that we work with communities in an open and honest way,
being realistic about potential outcomes on quality projects where
they can be proud of the results.

The second part of this chapter explores the issue of quality from
the perspective of the face-to-face Community Arts worker.

Can You Tell What It Is Yet?

by Kim Fuller and Sam Hale, Bostin Arts

We have all been there. That three-year-old you love – be it your own or one who has 'adopted' you as their ultimate, beloved critic – is standing at your feet, big-eyed and full of optimism. They proudly hand over a dog-eared piece of paper, on which they have laboured for hours, with much sharpening of coloured pencils; brow furrowed; tongue protruding from corner of mouth, pouring out their soul.

You gaze in delight at the image before you, thrilled that someone has spent such time and devotion creating something so wonderful just for you. You want to comment – discuss the subject, question the motivation, praise the use of colour, the texture, inspire them to greater things ... But all you can think of are Rolf Harris's immortal words: *"Can you tell what it is yet?"*

And this is the big debate within Community Arts – are we aiming for this high quality, wonderful 'life experience' process irrespective of the quality of the product? Or do we have a duty to ensure the quality of the product, maybe at the expense of the process used to create it?

Community Arts has become so many things to so many people it is impossible to make sweeping statements and cover every angle. At *Bostin Arts*, our work seems to divide into three distinct areas: consultation, production and self-expression.

a) In a consultation project, we are given an issue (maybe based on health or the local environment, for example) and employed to use art forms as a tool to talk with people and record their views.

b) A production project would be us employed to make a piece of art for a particular purpose – a decorative bench in a school, for example – and work with the people involved at all stages of the making process.

c) Self-expression projects are really about self-esteem – working with a group/individuals to talk about themselves, using an art form as a way of relaxing or breaking the ice, or to create something together as an achievement.

So which of these has a more important process than product, and why?

The arts worker has a whole range of issues to debate during the planning process – how public is the outcome, for example, what are the demands of the commissioning body, how participatory must the activity be? Lots of thinking and experience goes into choosing the right project, activity and product.

It is necessary to look at how much control the arts worker has over this process before drawing any conclusions, so let us go over some real projects.

We work a lot on health issues, and were delighted to get an 'unusual' contract researching the health of truck drivers. The process was consultation; to find out from real truckers what health issues affect their lives. The product, we decided, should be 'truckin' songs, based on our findings. The participants – more than 40 men, interviewed in parking lots and depots – had no active involvement in the product at all, except that their words were turned into lyrics. The report back to the health authority was the product the funders wanted, but the truckers responded better to us than to any clipboard because they were enticed by the art.

There was a great deal of press interest in the project, and the songs were played on national radio, therefore reaching a very wide audience. The product had to be good for our sake, as it was our work on show as much as the participants. A cassette of the songs, together with written health advice, was given back to the participants too – another reason to get it right. Yet the process was crucial to the funding, as we were paid more to find out about truckers' health than to produce good songs.

We work a lot with people with various physical and learning disabilities. Our aim is to always choose an art activity that is accessible to everyone within the group. We made a banner for a conference following sessions in 'special' schools with dozens of children. Each child had his or her face traced on acetate, then they worked to make a tissue collage of their face on paper, which was then covered by the acetate. The children chose their own colours and styles, but we had control over the finishing of the banner. Adults who went to the conference thought the banner was stunning. The children had enjoyed the process no end, and they recognised their hard work in the finished product.

In a similar situation, women sit around a table contributing to a textile wall hanging. They each work on their own bit, but with the right arts worker they will do much more – sharing skills, discovering new ones and at the very least putting the world to rights. The arts worker in this situation must keep a close eye on the whole picture, because the work is ultimately for public consumption, yet each participant must feel they have made a valuable contribution and not been 'overpowered' by an artist.

It is all in the planning – careful selection of materials, challenging yet manageable activities, timing to get it finished – the list goes on. Again, the arts worker must not set things up to fail: he or she will look at the final piece of work fondly, recalling the time spent making it. They will share a sense of achievement and recognise how difficult it may have been for individuals within the group to get so far – they will view the work sympathetically. But Joe Public knows nothing of this intimacy and pride.

This collective 'pooling' is perhaps nowhere more apparent than in a lantern procession. Groups and individuals work on their own making their lanterns, until all come together in the twilight to form a magical display. It seems like the essence of simplicity, yet the best displays will have gone through a rigorous process of planning by the arts worker. Our lantern processions are invariably themed, with each and every participant putting a bit of themselves into their lantern. As they come together, they 'ooh' and 'aah' at each others' creations, because they know the hard

work that has gone into making them. They have appreciated the process, they are loving the product and it is a quality of experience like no other. But if the arts workers have done the job properly, the bystanders lining the streets as the procession snakes by are overawed by the product too, knowing nothing of the process.

If you are with us so far, we are taking you through a kind of continuum of product responsibility. The truckers' songs could never be 'blamed' on the project participants, because they did not write them. Whereas an unfinished, rough-looking lantern could easily reflect badly on the carrier. At this end of the spectrum we could place performance projects. You cannot be on stage when Katie forgets her lines and Darren sings wildly out of tune. So a poor show can never be the responsibility of the arts worker, can it? And surely if they have enjoyed the process of the rehearsals, it does not matter anyway, does it? Their Mom and Dad will still love them…

Well hopefully, yes they will, but that is not quite the point. There is still this thing about not setting something up to fail. So the community members on stage with Katie are ready to speak her lines, and Darren will have a song within his range.

A good community show will also have the 'extras' – the lights, the costumes, the script, the set – so well in place that Katie and Darren will still be able to hold their heads high after the 'press crit'.

Community Arts workers have a huge responsibility to their participants, audience and funders. There is a distinct difference between an artist and an arts worker – the former has a duty to bring the best out in himself, the latter a duty to bring the best out in others. We find our artistic fields are made greener by the input of the group with which we are working, whereas the artist may say the interference made his field dry up. In our work, the whole is greater than the sum of the parts.

We are not teachers or social workers, yet the Arts is proving to be a very successful way of reaching people who have failed, or

been failed by, the system. We are inclusive in our working practice, and believe that the process of creativity is a wonderful thing, a growing thing and something wonderful to watch developing within a group.

But after years of working in Community Arts we now also believe that the product is just as important. No-one wants to spend their time working on something that does not hold up to public scrutiny. It is that old phrase again – *"you can't set it up to fail"*. The arts worker has a duty to plan a project at every stage to ensure the participants are getting what they need out of it, *AND* that the product will be right.

Justifying your role as an arts worker is hard enough in any event – *"You charge how much?!"* *"Surely all this money could have been spent on medical equipment!"* *"Well our Sally's good at drawing, they could have done that with 'er for a couple of quid pocket money..."*

You cannot afford any of these comments. You have got to go for the 'wow' factor every time, because you owe it to your participants to help them look and feel good about themselves. And if you are not doing it, there is no point in you being there.

That doe-eyed toddler with the dog-eared colouring may get the 'aah' factor from his loving Mom and soppy uncle, but take away the knowledge of the process and pin it up as community art, and listen to the reaction …

AAARRGGHHHH!!!!

Chapter six

In Perfect Harmony

Keynote: Partnership

The concept of partnership forms the basis of the way in which most elected and many non-elected institutions describe their relationship with the wider community. Recent years have seen a growth in its usage particularly in respect of the new government agendas around regeneration and urban renewal that have prompted the development of Local Strategic Partnerships (LSPs). But what do they actually mean by using the term 'partnership'? Is it just another way of saying we will do something for you, and in return you have to do something for us?

In business the concept has a clear definition. A partner is someone, usually another organisation, with whom you share an agreed goal and with whom you make an agreement over the supply of some resources or services. The Local Strategic Partnerships which now operate in most areas as a body to co-ordinate services operate in the same way, bringing public bodies together with voluntary and community sector organisations to devise strategies for working together to meet local needs.

In the funding of arts projects the concept often has another meaning again, and refers to the way in which funders get involved in projects. In this context, a partnership is sought between a funder, who wants to get something done but needs the involvement of someone else to do it, and another organisation who wants to do something but lacks the resources to do it. Short term partnerships are often made over projects. A project may have several partners but in each case there will be an understanding about a shared goal, the mutual responsibility of each of the partners, and resources.

In Community Arts work the partnership is often longer term in nature and blurs the distinction between project participants and

funders. In this way of working, the partnership itself is the product of the work as much as it is the means of achieving something. So a partnership is made between local groups, partly because they each have something that the other one wants, but also because through working together they can learn about the needs of each other, and build links that strengthen both the work and community solidarity.

For this reason, partnership is built into the work practice of Community Arts workers. For example, not only might we want a partnership with the local school because they have a hall we need, but because through linking with the school we may invite the interest of some of the students or their parents, or even make links which bring extra resources into future projects. Each partnership thus brings the work closer to the centre of the life of the community and makes it more accessible.

Community Arts organisations often describe their work as being in partnership with a local community to illustrate the fact that their aims and objectives are to foster long term relations with groups, and that they can be trusted not to disappear at the first sign of trouble. This approach is adopted partly to promote trust from groups but also to encourage groups to take on more responsibility in the development of the work in the long run.

The second part of this chapter explores whether developing a Community Arts service based on partnership is possible, given the way resources are now allocated and the regime under which local councils are being forced to operate.

Partnership and Regeneration

by Glen Buglass

Partnership

Fifteen years ago, the team was set up to deliver work in partnership with local people, to use the Arts as a tool to meet their needs and develop participatory arts projects. From the outset, we actively sought partners to deliver our work. The Community Arts Team has developed many partnerships with various organisations to deliver creative projects in the community.

The detailed nature of the partnerships are always different as no two organisations or projects are ever really alike, but broadly they fall into three categories: partnerships with community groups and individuals, non-governmental organisations together with other statutory organisations, and other local government services.

All partnerships made by the Walsall Community Arts Team have come about as part of our role as a local government service and meet the aims and objectives of the Council as a whole. Partnerships have become ever more important to our way of working because of changes in the funding of local government away from central funding to funds targeted towards specific social outcomes.

The broad parameters of who the Community Arts Team can best work with are those potential partners who want to use the Arts to fulfill one or more of the broad aims of the local authority.

The Council's main aims are:
> Ensure a clean and green borough.
> Make it easier for people to get around.
> Ensure all people are safe and secure.
> Make our schools great.
> Make Walsall a healthy and caring place.

> Encourage everyone to feel proud of Walsall.
> Make it easier to access local services.
> Strengthen the local economy.
> Listen to what local people want.
> Transform Walsall into an excellent local authority.
> (*Vision for Walsall,* 2003-8)

The Council's plan is linked into the national agenda so many organisations, not a part of the local authority, can also sign up to the same objectives that the local authority has. That means we can work with them too.

Communities

Since 1989, we have made partnerships with individuals and local communities in order to make an arts service for local people. We act as consultants, developers and enablers in some very poor areas of our borough to bring participatory arts into the heart of that community and to unleash the sense of pride and achievement that is the trademark of Community Arts.

We are concerned with creating partnerships to make the Arts for 'us' as well as 'them' and to put people's creative energies to work to be a part of the process that improves their quality of life. We are actively making such partnerships at the time of writing. It is something we do well and lies at the very core of what Walsall Community Arts Team is all about.

We always write some kind of simple document describing what we will do and what the community group will do in establishing our partnership with them. It is never high-brow, but it is always clear. We have hardly ever had to refer to the agreement again, but where we have had to, potential arguments about who agreed to do what are nipped in the bud.

Our role in the partnership, is in challenging people, in working with them, supporting them to fulfill an ambition and, let us not forget, in having fun. People who participate in the project agree, in turn to take a part in project decision-making and take part in the regeneration process that moves them and their community forwards.

Regeneration

In Walsall we are in the business of regeneration. Not just the regeneration of bricks and mortar, shopping centres and business districts, but the regeneration of Walsall's communities, increasing the skills and capacity of the people who live and work in the borough. We need to involve them in the regeneration of their town centres, ensuring they have a voice in how things will look once the council has finished its work.

An example of such a partnership was in Willenhall where the planning department wanted to engage the local population in a scheme designed to regenerate the town centre. As with all public spaces there were a number of different opinions about what regeneration or 'making it look better' actually meant. The Community Arts Team working with *Freeform Arts Trust*, the Local Committee and various professionals from the planning department of Walsall MBC, constructed a wide-ranging consultation programme, taking the work into the community and building the scheme with the active support of Willenhall People.

Willenhall has a proud industrial history, for many years the world centre of the lock and key industry, and local people clearly identified with that. *Freeform Arts Trust's* Andy Dwyer designed relevant modern public art interpretations of this industry that are now an integral part of the Willenhall Town Centre regeneration scheme. All of this was done in partnership with Willenhall people.

The strength of this partnership was in utilising skills appropriately. Public artists make public art. Planners design urban landscapes. Local people live in that designed environment and look daily at the artists' and landscape architects' work. Local people know their own local history. Community Art development workers and community artists are good at getting people talking about their knowledge, experience of and feelings about the place in which they live, and articulating their wishes for their environment.

The voluntary and non-governmental sector

Where there is a mutual interest, we have been quick to make partnerships with outside agencies from the non-governmental or the voluntary sector. These partnerships make sense because the main aims of our partners in these instances are very similar to our own. They may have an empowerment agenda, a regeneration agenda, a participatory agenda, or simply an encouraging and nurturing one. When we work together we can make better use of combined resources than just by working alone. However, it is important when setting up partnerships that some kind of agreement is drawn up about who is going to do what, give which resource and when. These documents are more formal than the ones drawn up with community groups, but their use is the same.

We have had a particularly fruitful partnership with the non-governmental organisation (NGO), the National Association for the Care and Resettlement of Offenders (NACRO), during the delivery of our seven year long Single Regeneration Budget (SRB 2) project Creative Learning Opportunities also known as *Hands On*. The NACRO project entitled *Youth Empowerment* was around the setting up of youth forums in seven poor areas of the Borough of Walsall. Our project was to work in the same seven areas with young people giving them access to education through the Arts. NACRO found that young people are not all that good at coming to meetings that involve any kind of structure and those in poor areas are even less inclined to put themselves out in this way. But arts projects are fun and young people like fun activity, especially fun activities that have been steered by the young people who are working on them. Both we in Community Arts and the workers in NACRO realised that if we worked **in partnership** to set up youth forums on the back of participatory arts projects, young people were more likely to attend youth forum meetings and make decisions about their next arts project and how to best to utilise their youth empowerment funds.

What was particularly gratifying about this partnership, was the amount of money young people voted from their youth empowerment budget (from which they could largely do what they liked), in the seven SRB 2 areas, to do yet more arts work. NACRO achieved their objectives by working in partnership with

us and we achieved our objectives and even more, by working in partnership with them. The real winners though, were the young people who got double attention at their meetings by attracting two differently skilled sets of workers and received a joined-up youth activities service that was working to satisfy their tailor-made requirements.

During the seven years of the SRB 2 funding over 500 young people achieved a Level 2 access qualification in Participatory Arts Planning by working with Community Arts and NACRO in this way. Three years later, at the time of writing, after the funding has long gone, we are still in contact with many of the participants, now young adults, still taking part in arts activities in and around where they live.

This partnership was a complicated one and needed careful monitoring through regular meetings between the two organisations to keep the mutual aims and objectives on track. It involved the two organisations, seven local committees and youth forums, arts development workers, community artists and youth workers. It is all too easy for partnership projects, especially ones with more than one partner, to slide towards the needs of one partner rather than another. Regular meetings keep partners talking and solving problems together. If the slide is not halted quickly, the partnership will break down and partnerships are hard to set up again once trust has been damaged.

Statutory agencies and local authority departments

A public health worker called into the office the other day and joked that she wanted to work with us because the Arts are seen as 'a magic bullet' in Walsall. Many a true word is spoken in jest. The Arts are not a magic bullet, clearly, but the Arts are particularly effective in engaging people who have not been engaged by other methods of consultation. As Matarasso notes, *"a little art goes a long way"* (Matarasso 1998, p85).

There has been much talk of 'joined-up government', 'joined-up thinking' and 'joined-up working' since the election of New Labour in 1997. Local Authorities are charged to deliver services that are identified by local people and change their management

practices to deliver them accordingly, but with a seemingly ever-reducing budget.

Since the Conservatives' reforms of the 1990s, Compulsory Competitive Tendering the creation of Direct Service Organisations (DSOs) and New Labour's continuation of these same reforms in the shape of 'Best Value' and now 'Putting the Citizen First', it is obvious to all with eyes to see, that the Government is interested in privatising as much of the functions of local government as it can, whilst still maintaining regulatory control over them. The idea is to reduce costs without relinquishing control of what public service actually does. A good discussion of the reforms making public services into quasi-private businesses is in Stewart and Walsh, *Change in the Management of Public Services* (1992), and in Seifert, Ironside and Sinclair's work (1996 and 1997) around the health service and state education, but the following quote sums up succinctly the reality of what has been happening:

> *"Best Value is likely to accelerate the out-sourcing of services and the reduction of staff directly employed in local government."*

(The (Local Authority) Employers' Organisation Strategy Paper, 1999, p2)

The effects of the reforms are wide reaching. All local authority services must now ask people about how they want their services to be delivered. This means working directly with local people. Organisations like the Community Arts Team offer a way into connecting with local people and getting those people to engage in the work of our partners.

We are not blind to another reason why people want to work with us. It is because we have the skills and experience to find those 'hard to reach' people, whose comments tick the boxes that accesses the money from central government. Making partnerships that attract funding is vital for the survival of the Community Arts Team in Walsall and more than ever before we have to competitively bid for money in order to continue our work.

We levy a management fee on all of our work which does not come from core funding from the local authority. This amounts to some eighty per cent of our work. We have done this to replace funds that have been cut from our council budget and to fund our growth. Currently we receive an investment of £150,000 from the council and turn that into about £1,000,000 worth of arts project work. Partnerships directly enable us to maintain our administrative support workers, two of the team's development work force, our equipment stock and financial flexibility. Without partnerships we would be a much smaller organisation than we are.

New partnerships, new challenges

> *"The bureaucratic form (of an organisation) emphasises the distribution rather than the centralisation of power and responsibility... The matrix form emphasises the co-ordination of expertise into project-orientated groups of people with individual responsibility...The matrix form has grown out of the bureaucratic form and is more usually found in organisations where exist complex patterns of working relationship and a greater emphasis on developing agreement than telling people what to do."*
> (Torringdon and Hall, 1998, pp92-95)

The Government reforms in public service require a new way of thinking, encouraging different approaches to solving the problems Walsall faces in the twenty-first century. As an organisation Walsall Council must find ways of harnessing the skills and talent latent in the organisation and developing more of the collaborative 'matrix' way of structuring and working and rely less on the bureaucratic ways of old.

Community Arts practice has always been around encouraging 'I can' and not 'I can't'. It is early days, but executive management in Walsall MBC has asked us, amongst others, to work with them to find creative ways around thorny problems, such as 'What is Walsall's identity?', and 'How do we put Walsall back on the map? 'How do we make Walsall an inclusive place for everyone?'. 'What should Walsall look like?' 'What should Walsall be known for?'

These are questions that the Borough must answer if it is going to move forwards in the next few years.

It could be the beginning of a development of a new kind of partnership presenting another raft of challenges for the team that prides itself on being accessible, on being a creative catalyst, and to find ways of moving people forwards, using the Arts, often in difficult situations and this time in our own community, Walsall MBC.

References

Department for the Environment, Transport and the Regions (1998) *Modern Local Government in touch with Local People*, White Paper, London: HMSO.

Ironside, M., Seifert, R., Sinclair, J. (1996) 'Classroom struggle? Market-orientated education reforms and their impact on the teacher labour process', *Work, Employment and Society,* Vol 10, No. 4, pp641-661.

Ironside, M., Seifert, R., Sinclair, J. (1997) 'Teacher union responses to education reforms: job regulation and the enforced growth of informality', *Industrial Relations Journal*, February, Blackwell.

Matarasso, F. (1998) *Use or Ornament. The Social Impact of Participation in the Arts,* Stroud: Comedia.

Stewart, J., Walsh, K., 'Change in the management of public services', *Public Administration*, Vol 70, Winter 1992, pp.499-518.

Walsall Metropolitan Borough Council (2003) *Vision for Walsall 2003-2008,* Darwall Street, Walsall.

Chapter seven

A Different Beat

Keynote: Local People and Local Issues

One of the barriers to effective work in communities is that many practitioners are reluctant to talk in a practical honest way about some of the real problems that confront them as workers. Equally, activists and volunteers within communities want to steer conversation away from the problematic because the issues it raises are too complicated and far-reaching to be dealt with through single projects or simple strategies. Understandably they are worried that it would also have the effect of painting their communities as dysfunctional or as a hopeless case instead of a place where positive change can occur. Toolkits and handbooks often do not really refer to potential problems or they aim to give simple solutions to what are absurdly complicated issues. This explains the cynicism that many people have when it comes to undertaking projects in communities. Local people do not feel there is a commitment to deal with the real problems; workers do not feel they can effect real change.

Nevertheless, there seems to be an increased dependency on the need for the quick fix, the 'one size fits all' solution which will solve all those knotty, difficult, untidy problems. Against this background, the Arts are increasingly being seen as an effective tool and panacea in the regeneration of communities and in countering the worst effects of social exclusion. Usually this is because other measures have not worked quickly enough or have proved ineffective at getting beneath the surface. While the premise of this book is that the Arts can be an effective method for engaging with people and working with them on their issues and concerns, it is also important to give due regard to the real problems involved in working in places and with people who have been starved of resources and opportunities for generations.

A quick glance at any of the glossy regeneration magazines would give you the mistaken impression that the government based in the English Parliament is happily devolving power and resources to communities in order that they can find local solutions to local concerns. While there may be some element of truth to this in Wales and Scotland, where spending powers and privileges have been devolved to the national assemblies, this is of course far from the truth when it comes to talking of the English regions. If anything, decisions are now even more concentrated in Westminster and the policing of resources more concentrated in quangos and the civil service than ever before. The government, of course, likes to think it can have it both ways. On the one hand, official government policy is based around the stated aim of giving power back to the communities, while on the other, it steers local policies with an increasingly heavy centralist hand and does a lot of invisible backstage work to make sure it gets its own way. This has caused untold damage to a lot of community initiatives and sometimes has had the effect of putting them back years.

One example in recent years has been the government's asylum dispersal policy which has seen traumatised people, many escaping from the kind of experiences that leave them stressed and distrustful, quite often without being able to speak English, being dispersed to communities without any preparation either for them or for the host communities. This has led to huge tensions both between asylum seekers and host communities and within asylum seeking communities, and was no doubt a central factor in sparking off the disturbances in the Northern cities in 2001 and 2002. As a result of these civil disturbances a whole new raft of policy and philosophy was invented around the concept of 'community cohesion' that had funding attached. This has lead to a bustle of activity on a local level with themed projects and money to local organisations to develop and deliver programmes bringing communities together to share their experiences and to build long term links. So, after having caused the problem through insufficient preparation, the Government attempted to put matter right by spending money. Not surprisingly, many of the projects and programmes have utilised arts and cultural work.

Many argue that the problems within communities were not caused by asylum dispersal but that asylum dispersal brought out rivalries, divisions and resentments that were already there. This may be true, and if it is, it may also add weight to the accusation that the Arts have provided just another sticking plaster to cover a gaping wound; another strategy tampering with the effects rather than dealing with the causes. The fact remains, however, that Community Arts practice should work on a profound level. It needs to work through superficial problems and help provide long-term solutions. It can be an agent for change and agitation, but equally it can be a vehicle for healing rifts and bringing people together.

Social problems and conflict in communities do not have a quick fix. Short-term projects will not bring about long-term solutions without a commitment to long-term goals and an open and honest process. Community Arts can be, and has been, a catalyst for positive change but it needs to be administered with a rigorous attention to its values, philosophy and ethics. It is not something that can just be smeared over the surface of problems in the naive hope that something may stick. Nowhere is this more evident than in some of the arts work over the last few years that has been developed with young people.

The term 'anti-social behaviour' is quite old, but the concept is relatively new. It is another example of a terminology that has been developed in response to a need to be seen to be doing something. The stated aim of the Anti-Social Behaviour legislation was to give local communities and local police forces the power to deal with repetitive offensive behaviour, particularly from young people. While in some cases it has been used effectively, the net effect has been to stigmatise and isolate further, groups of people that the majority find difficult to understand. It has worked counter-productively and counter- intuitively to good community work. Rather than drawing communities together to search and explore common ground and find solutions, the legislation has pushed a huge wedge into community relations and created a new and fragmented way of looking at the world. A world where young people, forced to socialise on the streets as a result of government policy which has

seen the devastation of youth clubs and youth resources, are now engaging in 'anti-social' activity. Where, ten years ago their behaviour may have been labelled high jinks, or just plain naughtiness, it is now seen as criminal. Where once, a good community worker may have intervened and dealt with the problem by utilising good youth work practice, the problem is now labelled as criminal, before anything criminal has actually happened, and the agencies that have to deal with it are the police and the criminal justice system.

The net result has been to demonise and isolate young people further from the communities in which they live. This is yet another example of where a government initiative which had a stated aim of putting power back in the hands of the people has had a contrary effect. It has put the power back in the hands of adults to use against young people without involving young people in the discussion about what is acceptable behaviour. As a result it has heightened conflict between the generations rather than dissipated it. This legislation has run directly counter to the Government's stated policy of working towards Community Cohesion, for while communities concentrate on what divides them they fail to focus on what keeps them together. The outcome is a growth of distrust and suspicion and an actual reduction in that commodity which some people call community spirit and others have called social capital, but which we refer to here as community empowerment.

One thing that can be learned from recent asylum legislation and Anti-Social Behaviour legislation is that unless communities find sustainable ways of building solidarity, relatively small events or low level irritations can blow them off course. Short-term government strategy while providing welcome resources can end up doing more harm than good, even when well intentioned. The second half of this chapter concentrates on how the Arts can provide a mechanism for working through local, often contradictory issues, and how it can provide a solid dependable route to building sustainable long-term change.

Young People, Issue-based Work and Conflicting Values

by Deb Slade and Jonathon Maddison

Why work with young people?

Since the 1950s and the birth of Rock and Roll, the notion of a separate stage of life during teenage years has developed into the massively hyped youth culture of today. Over this time the terms 'teenager' and 'delinquent' have been used as an adult response to young people who were seen as rejecting society's norms. Over the period the traditional rights of passage and rituals around entering the adult world have been eroded. A young person may no longer have 'starting a job', or 'getting married and starting a family', as a normal progression to adulthood. During this time there has been a huge growth in commercialism putting pressure on young people to keep up with the trends . For young people the desire to be different from the mainstream opens an ever-changing market to produce the latest look/sound/thing. Youth Culture is big business.

Challenging the norm and being different is the way that society develops. A young person's natural growth into adulthood needs the to-ing and fro-ing of power to develop from the dependency of childhood to the independence of adulthood. Young people are society's future. We need to give young people the opportunity to develop the skills of independent thinking, negotiation and positive ways of communicating and expressing themselves. If we do not, disenfranchised young people become disenfranchised adults without a sense of belonging to, being responsible to and for, society in general. Being involved in an arts project can begin the process for young people in helping them to express themselves, be creators and not just consumers, and may help to build bridges between the generations within a community.

Walsall, like many Local Authorities, has been in the process of developing neighbourhood and district committees and, more

Recently, Neighbourhood Partnerships. As a result of its efforts to engage young people in the process of regeneration it has been successful in gaining funding through government initiatives such as Single Regeneration Budget and New Deal for Communities. The NHS Teaching Primary Care Trust has also been successful in programmes such as *Health Start* and *Health Action Zones*. These all come with the proviso that local people must be involved in decisions for community improvements and the expenditure of the funding, supported by the professionals.

Community cohesion is a common theme to be addressed at a neighbourhood level. Young people are frequently cited as a problem. The most benevolent of the local community will see them as in need or 'at risk' (of being victims or perpetrators of crime). At best, these largely adult groups will recognise the lack of facilities or activities and involvement for the young, and that young people with nothing to do are causing mischief on the streets. At worst, young people will be seen as out of control, terrorising the local neighbourhood. The threat may be real or it may be perceived. Any planned intervention may have good intentions and perhaps be aimed at giving young people something to do. At best it will attempt to engage with the young people and perhaps involve intergenerational work.

The attraction of using the Arts as a tool to engage particularly disenfranchised young people is that it is a fun, non-threatening and voluntary way of addressing issues which is far more likely to work than sanctions, lectures or punishments. It is, however, a drip, drip approach to changing attitudes and behaviour and not an instant remedy. The challenge for the arts worker or project manager is to work out some tangible way of defining and measuring success. Those who blame the young people may object to those very people who are 'doing wrong' being offered what they would consider a treat.

What they will not see is that after the initial attraction of being given the chance to take part in a spray art project, for instance, they will need to go through the process of practicing, negotiation, communication and self expression and to address the appropriateness of imagery and placement of the art work. They may even need to run the design past community representitives.

They are, therefore, developing a sense of ownership within the community but also taking into account the needs and desires of the rest of the community.

Working with issues

Governments, statutory bodies, local authorities and media organisations, identify and attempt to address with varying degrees of enthusiasm, 'issues'. These, generally, seem to be approached from the perspective of righting the ills of society, and must be assumed to be driven by a range of motives which are likely to be based on a particular political, economic or moral analysis. Policy implementing bodies are becoming aware of the value, power and efficacy of Community Arts methods. Increasingly, the conept of using art as a tool or vehicle for debate, education, consultation or communication, usually in an attempt to move towards some kind of siciual improvement, is accepted by these bodies.

All of these bodies will have developed polices to address specific issues, based on whatever research they have used. Those working in Community Arts will be familiar with issues around sexual health, drugs, and safety with regard to young people. The issue for managers of arts projects is to find a way of attracting young people to participate in a project around an issue they may not consider relevant to them. If there is a clear and shared agreement from commissioning agencies and funders through the arts workers to the participant that the chosen issue to be addressed is the priority and the ground rules are clear, this need not be a problem. Unfortunately, this is not always the case, and issue-led work can be a double-edged sword, often because the young person's opinions and circumstances are out of kilter with the approach. This is not altogether surprising since one could argue that the very reason for specific, issue-led work with young people is due to failure of agencies to effectively engage with them.

It is vital that the project manager is sensitive to creating a fine balancing act - so that the young people get their needs fulfilled, stay interested and the project gets a positive profile with the wider community - something tangible that can be heard, seen, or felt. In Walsall, an area of high deprivation, Blakenall, secured

New Deal for Communities funding and the NHS Teaching Primary Care Trust have gained *Health Start* funding for projects as defined by the local community. The Community Arts Team responded to the issue of young men's sexual health needs by developing a project called *Making Connections - up for it.* Two organisations were brought together to deliver the project; Walsall Youth Arts, an organisation dedicated to the delivery of arts training to young people, and *Walkways,* an organisation offering detached youth work. The project also linked into local heath services via the (male) Community Nurse based in the area and funded through *Health Start.*

The three year project has approached a number of local issues from a number of angles and has had to deal with a number of local issues including a particular group of young men being seen locally to be behaving in a generally undesirable manner for long enough to be labelled and to be banned from the local community centre. This represented a difficulty that had to be overcome as that venue desperately needed to host some of the planned arts sessions.

Through being part of the *Making Connections* project the young men were cautiously allowed to use the venue. After several sessions that involved both health awareness and arts activities such as DJ-ing, silk-screen printing and break-dancing, the local sceptics had to admit that the particular young men had been seen to participate and behave in an acceptable manner. This was a major shift in perception both for the members of the local community who came to see that the young men were not all bad, and for the young men, who came to see themselves out of their usual pattern of behaviour and not in conflict. How to maintain and develop trust between the young men and the local community centre beyond the life of the project is part of the task for this, the last year of the project. Whether the temporary shift in the young men's perception of their place in their community made any fundamental, if subtle, difference to their future life choices may be impossible to measure, but for a time at least it will have boosted their self-esteem.

Conflicting values and interests - the quest for a positive compromise

Most of the time funders will want something concrete and specific out of a project, and there is nothing wrong with that. The various agendas must be reconciled first. A funder, however, like the other stakeholders, is doing the project to meet a need of their own, whether it be altruism, market profile or government policy. Sometimes there is potential for their needs to hinder or even prevent the potential benefit to participants of a given project.

It is all too tempting for those working in Community Arts to apply for money 'because it is there' rather than because it funds what young people really want or need. Even if you can persuade the youth club to turn up and work on, say, a drugs information poster, how much will they really gain from discussions that they do not want to have at that time whilst perhaps inhibiting the ones they do need to have? Will the level of technical skills learned and quality of artworks produced be fatally undermined by producing a piece that none of them want while ignoring their real ideas?

Questions must be asked, not only about who is funding the work and why, but about who is really asking for this issue to be addressed, and what issues would have actually been chosen by young people themselves. Is the young person missing from the equation?

Given the right opportunity any young person will voice questions and opinions about issues both personal and general of their own volition. It is important for their personal development and involvement in their community that they should have access to suitable opportunities to explore these and perhaps other issues they had not thought of.

It is essential to consider how a project can realistically be implemented to enable all stakeholders to feel that they have benefited in some way. Order of priority may vary from time to time and compromises may be made because of other benefits a specific project may offer, but funding should not be accepted if it

does not meet the needs, aims and objectives of one's organisation. Indeed, the careful organisation might be well advised to reject opportunities where it suspects any of the stakeholders, particularly participants and their communities, will be disappointed. A project gone wrong can be much worse than no project at all.

In the case of a recent project, *Safety Soapbox*, run by Walsall Youth Arts (WYA) in collaboration with Walsall Community Arts Team as part of wider research for Walsall South Health Action Zone (SHAZ) the stakes were particularly high. Research had been commissioned by SHAZ in this area where street prostitution is seen as a serious problem and the partnerships and various agendas were complex.

The project worked with local residents, female sex workers and young people 'at risk' in sheltered housing in the red light area, to produce visual arts expressing various opinions from these three different groups. Obviously there were widely differing views and in order to engage with the different groups, clarity about the arts project and its aims were essential.

Arts worker, Kate Green, working with the researchers carrying out the wider project, consulted with each of the three groups and developed the theme of safety as one that despite their different experiences, sex workers, residents and young people all agreed was a key concern. An issue that all could agree on, clarity and honesty about aims and process and a realistic description of outcomes, combined with a professional and neutral but supportive approach, enabled the project to be very successful.

Information and individuals that might not have been accessed from more traditional approaches were communicated in different and richer ways to a wide audience through showing of finished work in a variety of settings. Views from people who generally want nothing to do with each other were able to be presented together effectively, emphasising the over-riding concern of personal safety. This could be clearly seen as relevant by partners such as the teaching Primary Care Trust, police and community groups, as well as participants.

This project demonstrates that when common ground is found, individuals and agencies with apparently conflicting agendas can work effectively together.

Whose project?

In all, when developing a Community Arts project aimed at working with young people, consideration must be given, despite the many other agendas that may be at play, to young people's engagement to the project. The agendas presented by the funders, partners, local community, the issue to be addressed, and indeed the agenda of your own organisation, will pull a project in different directions if allowed. Careful negotiation and clarity all around can keep a project on track, but if we exclude young people themselves from the equation the project is in danger of failure. Young people, their needs and interests, must be central to our planning processes and the Arts can be one of the most powerful tools in involving, engaging and empowering them.

Chapter eight

When the Music is Over

Keynote: New Directions in Community Arts - Arts and Health

When we produced the first edition of this book, the Community Arts Team was looking out at the world from a very Walsall-centric focus. In those pre-Blair days words like 'choice' and 'empowerment' still sounded new and exciting. We believed that what we were doing was innovatory and we knew that we had started to influence how other major services thought about their services in the Borough. We were, however, still a peripheral organisation, even if we claimed to be mainstream. The final chapter in the first edition ended by announcing to the world that the Community Arts Team in Walsall had come of age and was now a fundamental part of mainstream services. This was perhaps a little optimistic in its interpretation of the reality at the time.

By the time the book was in print I was living in Spain. Two years after the book was published I returned to the Team as the Arts and Health Development Worker. A post created in partnership with the then Health Authority - later to become the Teaching Primary Care Trust. Kate Gant, a founder member of the team and the then team leader, secured the partnership based on several years of health-based work that the Team had been undertaking with the Health Authority.

Many people asked me why I was tempted back to Walsall from the sunny climes of Barcelona to take this post and indeed I had to think very hard about it myself. Reflecting on the decision now it is patently obvious why. What the post represented was the thing we had been claiming for years and was now true - that Community Arts offered a way of working that could add value to all services. It could increase their effectiveness and impact; it was a new way of looking at the world that could profoundly

change the way communities accessed and utilised services, and could influence the way that service deliverers thought about their services and how they delivered them.

What I did not realise was that in the three years that I had been away there had been a shift more profound than even I had anticipated. I came back still expecting to have to convince people that the Arts had a role to play in health and that participation and creativity could foster new ways of working that could improve health. I fairly soon found that I could put my missionary zeal to one side. In fact, my new colleagues in the Health Authority were way ahead of me as were many of the communities I would be working with. They had been participating in Arts and Health projects for a number of years, they had seen the results and they wanted more. In addition the new Health Action Zones (HAZ) had also brought together representatives from local communities who had a budget and a brief to develop new innovative ways of tackling intractable health issues in some of Walsall's most deprived communities.

These were people who wanted to make a change that would be long lasting and permanent and they did not really mind what tools they had to use to do it. If the Arts worked, then let us use the Arts, was their philosophy. I remember going to one HAZ meeting in the first week after my return and being asked how an arts project may help them to reduce the number of people dying of heart attacks over the next eight years. I took a gulp and then a leap of faith and suggested that the Arts could be used to engage with people who never come into contact with mainstream services, and that it could get them to think about their own health in new ways. To their eternal credit the group did not tell me to get lost, in fact they turned up on a Saturday morning to plan some projects. That morning we came up with the idea of using humour to improve the health of men. Why humour? Because men do not access health services as a result of the fear of what they may find out or have to do. And humour, as everybody knows, is the best way to counteract fear.

Before I knew it, we had a project that ended up taking stand-up comedy into pubs along with health workers running clinics in the back bar. Projects that followed included *Truck Stop Rock* a

music project around health issues with long distance lorry drivers, and *Pain to Call*, a project that took theatre into super-markets, clubs and health centres and aimed to reduce the time that people took to make the first phone call after the appearance of the first symptoms of a heart attack. It was not just heart disease. Within the first six months I was co-ordinating 16 projects across the Borough tackling issues as diverse as mental health, heart disease, drug education for the over 60s, prostitution, teenage pregnancy and sexual health. The Arts were being used to engage people, educate people and empower people. More importantly it was changing the ways in which health professionals thought about their services. Community nurses were taking their services to pubs, clubs and transport cafes. GPs were bringing in artists to work in their waiting rooms. The education service even worked with the Team to appoint an arts and health worker to work exclusively with them to develop arts projects in the Personal, Health and Social Education Curriculum across the Borough.

This exciting period of my working life showed me, for the first time, that what we had been claiming for years was in fact true. Community Arts could be instrumental in making monumental changes that could improve the quality of life of ordinary people, but it could not do it on its own, it needed to do it in partnership, with people, with services and with other organisations. As a way of working it demanded that people think in new ways. The projects were successful because they involved artists working in multidisciplinary teams with health professionals and the community, and together we evolved new ways of working that were neither arts-based or health-based, but were arts *and* health based.

Arts and Health is now an established way of working. The Arts Council now even has its own Arts and Health Officer and is developing a national strategy. By the time I left the team for the second time in 2002 the Walsall Teaching Primary Care Trust was the biggest single funder of Community Arts projects in the Borough. Although interesting in its own right, what happened in Walsall with regards to health has been mirrored across the country. The Arts is now embedded in the work of many health

organisations and is playing its part in such mammoth projects as the rebuilding of the whole hospital capital infrastructure. However, what I have described here is the way Community Arts have become an important and integral part of just one major service and how it has helped improve the quality of life for its service users. Walsall's experience illustrates graphically how the world has changed over the last few years. The processes involved in Community Arts really have now moved centre stage and become part of the bonding that brings people closer to the powers that influence and shape their lives.

The Keynote of this chapter is *New Directions in Community Arts*, and although it has focused on health it could equally have concerned itself with any of the big issues involved in regeneration and change. What it serves to illustrate is that the new direction in Community Arts is that it is now being adopted as a methodology by service providers and policy makers across a wide spectrum. It is seen as a credible methodology. Time will tell us if it is really capable of preserving its values while adopting such large and ponderous bedfellows, and whether or not it can maintain its popularity with its new partners when they realise the consequences of taking a Community Arts approach.

Private Parts: an Arts Approach to Men's Health

by Julia Holding

Walsall became a Health Action Zone in 1999, the success of its bid owed much to its commitment to include local people in the decision making processes around identification of local health needs, and measures to address them. Walsall Health partnership took the unprecedented step of devolving over a million pounds of the HAZ budget down to a local level.

The structures set up to ensure this funding was used effectively hinged on the establishment and support of four locality steering groups, with boundaries then co-terminus with the four Primary Care Group areas (PCGs). Each steering group had on it representatives from neighbourhood local committees, and Health Watch Groups. Each of the steering groups was supported by a public Health Worker. These were community development workers with a health brief who worked both to support the group and to co-ordinate the commissioning and implementation of projects. Other professionals from a variety of organisations attended the HAZ steering groups who also enjoyed strategic support from the local Authority, and other NHS agencies.

From their inception, discussion within these groups focused on the Health Inequalities agenda, with priorities for localities being identified through a process of information gathering then often heated discussion mostly during Saturday workshops.

It soon became clear that the steering group needed to identify ways of effectively reaching out to those groups least likely to engage with services. Walsall had a history of using the Arts around issues of social inclusion, and health improvement, and the addition of an Arts into Health facilitator to the professional support team for the steering groups, offered them an option, which certainly in East Walsall they embraced enthusiastically.

Why men's health?

Health Inequalities work had traditionally focussed on where people live. The East HAZ steering group identified inequalities in the way men versus women accessed health services. They had identified the fact that local GP waiting rooms were full of women, and that local and national health data suggested that men were presenting with symptoms of illness later and therefore more likely to have a poorer chance of recovery. The group discussed the possible reasons for this. One of the barriers identified was fear of the consequences of ill health. Another was the reluctance of men to acknowledge and therefore overcome it. Other discussion revolved around how to get men to access information and support to initiate lifestyle change.

We needed to take health to men; where they were, when they were there, and information needed to be delivered in a form that would appeal to them. The places chosen to initiate the work were pubs and working men's clubs, and the 'Art' was stand-up comedy.

Stand Up Check Up **(Men's Health 2000)**

Ten pubs and working-men's clubs were identified. Criteria for selection was mostly based upon venues in East Walsall with a predominantly male clientele, where there were landlords happy to host the sessions. Some steering group members expressed anxiety about 'nice' nurses and arts workers going into what they termed as 'dodgy' pubs! These were largely the ones we targeted.

The initial session in each of the venues was set up for our comedian to gather material for the routine. Here the performer/comic/actor and another arts worker interviewed men about their health experiences, while two community nurses or health visitors offered health MOTs and lifestyle interviews in a corner of the venue. At most of the research sessions we also had in attendance a health and fitness advisor, who talked to men about increasing their levels of physical activity by building it into their existing daily routine.

The second phase of the project involved revisiting venues with the same team, and this time performing the comedy routine. We

found that in the main audiences had swelled, due to the 'bring along your mates' factor. This was especially so in the more traditionally male venues.

The work succeeded in generating a huge amount of publicity, from local papers and TV, to national and international news programmes. This in itself succeeded in not only raising the profile of men's health, but also in challenging the concept that the only place effective health intervention could take place was in a clinic or health centre. Conversations with arts workers stimulated discussions within groups of men, and acted as a lever to get them to have a check up from the nurses.

During our evaluation some of the nurses commented that the men they saw reported that conversations with the arts workers, and subsequently within their peer groups had not only motivated them to have a health check, but also had given them the opportunity to think through and to personalise some of the issues. These issues could be further explored during the one-to-one session with the nurse. Arts workers involved in the project felt supported by the presence of professionals who were on hand to provide some more expert health information when questions arose.

Following this initial phase the project steering group were keen both to take advantage of the momentum from the *Stand Up Check Up* and also to engage with men at a more profound level. *Stand Up Check Up* had revealed a lot of local talent in some of the pubs and working men's clubs and the steering group were keen to tap into this for their next project. In consultation with local men and two working men's clubs, it was decided to engage a drama development company to work with local men to develop two health-based variety type shows. This phase of the project became *Private Parts*, men's health and drama.

The rationale for this work was that if we could build the capacity for men themselves to become vehicles for relaying health messages to their peers, there would be more chance for the conversations subsequently generated, being continued. There was also growing evidence about the value of drama as a vehicle for

self-expression and the part it can play in awareness raising, personal growth, and the building of self-esteem.

The shows used very different formats, with the drama development work being tailored to the needs and wishes of the participants. One club delivered a health-based variety-type show with songs and sketches; the other used a game show approach. There were nurses present at some of the development sessions and at both the performances.

More generally, the opportunity for nurses, health and fitness advisors and arts workers to work together to design and implement the project, was one which added value to the work done by the individual professionals. It also stimulated discussion and learning. For the nurses it offered the chance to broaden their public health experience, and to open their eyes to alternative ways of working.

This way of working also challenged a lot of assumptions about the role of the NHS and lead to a number of as yet unresolved issues about integrating new and challenging ways of working into mainstream community nursing and health visiting practice.

The nurses and health visitors who have been committed to the work were initially contracted to the project on a sessional basis. Subsequently, there was some strategic commitment to providing this type of public health opportunity for practitioners, however, this failed to gain the operational support necessary to release community nurses from other work. The result was a small but dedicated band of Health Visitors, Student Health Visitors, and a Nurse Practitioner who all gave up a lot of their own time to ensure the success of the project.

This group has had the experience of seeing the positive effect of using Arts into Health. They have become a lobby group from inside of the health profession, and active advocates for this way of working.

This project provided opportunities for staff to work in creative ways to address health inequalities. But did it achieve what it set out to? The big challenge with the modern NHS is to justify the

use of resources, for the greatest benefit of patients (or potential patients). So what were the cost benefits? Using Arts and Health is not the cheapest approach to use and it is important that just like any other professional group, the skills of the artist and the quality of the work is valued. Thus, there should be adequate resourcing to ensure this is the case. Relationships between arts workers and health workers must be based on mutual respect and genuine commitment to partnership. When this is achieved the results can be inspiring. It encourages health professionals to review traditional ways of delivering services, and enables them to build the confidence to challenge traditional thinking around how people should receive care.

For participants, this particular piece of work provided the opportunity and stimulus to talk, in some cases for the first time, about their health.

End Note

In a strange sort of way the book finishes in the same vein it started. Although the first case history and the last were written almost eight years apart, their authors were both people who were not trained in the Arts or who had Arts in their job title. The first was involved in Community Arts when he was a Church of England vicar, and the second when she was an NHS public health worker. What unites them is that they both came to Community Arts through their work and saw that Community Arts could help them achieve what they wanted to do more effectively than any other approach. What they also have in common is that they were prepared to embrace Community Arts because it shifted the power balance away from institutions and gave people the power to be confident, informed participators.

In many ways this sums up the context for the ongoing discussions in Community Arts. The Community Arts Team in Walsall has always argued (and still does) that the Arts are a great tool for engaging with people around issues and for working with them in partnership. The outcome of this approach has been that other services and organisations that need a closer working relationship with the public have been very enthusiastic to adopt it as a tool. The message of the book, in so far as it can be said to have a message at all, is that Community Arts comes as a package with a set of principles. It is not possible to just simply pay lip service to these. It is about giving people access to the means to participate in the making of culture and through this participation gain greater control of their environment.

The popularity of the Arts in all aspects of regeneration means that Community Arts is presently enjoying a high profile, especially where services are saying they want to encourage participation. The danger is that there may be those who just wish to buy-in the magic and are not keen to sign up to all the principles. These will be the first to abandon the Arts when the money dries up or when the focus changes in government funding. On a positive note, I can count many colleagues and friends from a whole range of backgrounds and professions who, having worked through the process, have become convinced about the power of participatory arts and are up for the long haul. The next few years look set to be very interesting. It will be intriguing to see where the discussions will have moved to by the time we are ready to produce the third edition of *Finding Voices, Making Choices*.

Mark Webster

About the contributors

Maxwell Bailey undertook formal arts training at Wolverhampton University and the University of Central England. Before joining Walsall Community Arts Team he spent 10 years as a freelance visual artist, printer and photographer, working in Britain and abroad, principally in Asia.

Glen Buglass is Principal Arts Officer at Walsall Community Arts Team. Glen has been working in the team for the past ten years. Before that, Glen was, at times, a musician, an actor and a teacher. He is married and lives with his wife Marianne and their two daughters in Tamworth.

Kim Fuller and Sam Hale are two members of Black Country-based *Bostin Arts*. They are part of a team of four core workers, two male and two female, which has been together for more than ten years. *Bostin Arts* works on a contract basis for councils, health authorities and private organisations, in settings varying from prisons to doctors' waiting rooms. Between them they cover a vast number of art forms including sculpture, graphics, textile work, creative writing and puppet making. Sam is an accomplished painter and textile worker, Kim is a qualified journalist and published singer/songwriter. They both co-ordinate team projects, and employ other arts workers through their occasional work in arts development.

Jonathan Herbert is the leader of the Pilsdon Community in Dorset, a Christian community offering hospitality to all-comers and particularly those in need. Previously he was Vicar of Beechdale Estate in Walsall 1991-1996 where he was involved in developing innovatory Community Arts.

Julia Holding Julia has worked for the NHS for 23 years. Her journey through general nursing, midwifery, health visiting, public health, and now leading patient and public involvement with a strategic health authority. She woke up to the use of Arts in health whilst working as a public health worker in Walsall, and as a result of this experience has been a determined advocate for its use as a tool to achieve positive change in the NHS projects.

Jonathan Maddison is Co-ordinator of Walsall Youth Arts, a managing rather than a face-to-face role, in a small charity delivering arts and media training for young people in Walsall. Coming from an academic background he initially participated in projects as a young volunteer, serving time on the management board before working in a variety of roles for the organisation.

Debra Slade is a fine arts graduate. She decided she needed to work with people, and started as a volunteer in an inner city play and youth centre. From then she followed a path of full-time play and youth work for 8 years, gaining a youth work qualification along the way, and became a trainer for youth and playworkers involving arts skills whenever and wherever she could. She then spent four years freelancing as an arts worker and trainer before starting work with Walsall Community Arts Team, initially part-time, over five years ago and now takes a management role in the Team.

Mark Webster works as a Senior Lecturer at Staffordshire University. He was a founder member of the Walsall Community Arts Team and was responsible for editing the original version of *Finding Voices, Making Choices* while living in Spain. After three and a half years abroad he returned to take up the Post of Arts and Health Development worker with the team before parting company for the second time in 2002. People still ask when he is going to have another leaving party.

NOTICE

Finding Voices, Making Choices
(new edition)
is the lead book in a new series

Community – Creativity – Choice - Change

The series has been created to give a platform to new ideas
in Community Education, Life-long Learning and
Community Arts. All the titles in the series aim to give
voice to alternative perspectives in contemporary practice.
The series editor is Mark Webster.

Informal Education (new edition)
is the second book in this series.

Further titles are planned on Health and Community Issues,
Youth and Community Issues,
and Community Values and Home-based Education

New edition: **Informal Education:**
conversation, democracy and learning

by Tony Jeffs and Mark K. Smith

Of late there has been a major growth of interest in informal
education. But what is it? Who does it? How is it to be
developed? This book provides a unique and practical
introduction to the area. The writers focus on the central
features of the work. They examine the following issues:
engaging in conversations; encouraging learning; fostering
democracy; attending to product, process and education;
thinking about ethics; and planning the work.

ISBN 1-900219-29-8 price £10-00

For enquiries or renewal at
Quarles LRC
Tel: 01708 455011 – Extension 4009